PORTSMOUTH
IN
50
BUILDINGS

GARTH GROOMBRIDGE

AMBERLEY

First published 2017

Amberley Publishing, The Hill, Stroud
Gloucestershire GL5 4EP

www.amberley-books.com

British Library Cataloguing in Publication Data.
A catalogue record for this book is available from the British Library.

ISBN 978 1 4456 6406 4 (print)
ISBN 978 1 4456 6407 1 (ebook)

Origination by Amberley Publishing.
Printed in Great Britain.

Contents

Acknowledgements

In his research the author has referred to, or quoted from, a number of book publications – the details are below. Many of the following can be found in the local Southampton, Hampshire County or Portsmouth City libraries: *Buildings of Portsmouth and its Environs*, David W. Lloyd (1974); *The Spirit of Portsmouth: A History* (Phillimore, 1989); *Portsmouth: The Old Town*, Peter N. Rogers (Halsgrove, 2008); *The Pubs of Portsmouth*, Ron Brown (Amberley, 2009); *Images of Portsmouth*, Sarah Quail and John Stedman (Breeden Books, 1993); *The Portsmouth Beneficial School 1755-1939*, Lawrence V. Gatt (*The Portsmouth Papers*, 1986); *Southsea Past*, Sarah Quail (Phillimore, 2000); *Churches, Chapels & Places of Worship on Portsea Island*, John Offord (1989); *Portsea Island Churches*, Rodney Hubbuck (No. 8, *The Portsmouth Papers*, 1969, revised 1976, published by Portsmouth City Council); *Cinemas and Theatres of Portsmouth*, Ron Brown (Amberley, 2009). In addition I am especially indebted to Nigel J. H. Grundy's *W. L. Wyllie, R.A. The Portsmouth Years* for the history of Tower and Capstan Houses; Graham Claxton's booklet *A Portrait of a Church: St Jude's Southsea* (1993); *Portsmouth Reborn: Destruction & Construction 1939-1974*, John Stedman (1995); David Francis and Peter Rogers, *Portsmouth in Old Postcards* (1985); *The Cinemas of Portsmouth* by J. Barker, Ron Brown and W. Green (Milestone Publications, 1981); *Maritime City: Portsmouth 1945–2005* edited by Ray Riley and the Portsmouth Society (Sutton, 2005). Another invaluable source was the 1987 updated reprint of William W. Gates' *The Portsmouth That Has Passed*, edited by Nigel Peake (Milestone Publications), delightfully opinionated but also full of facts and statistics.

The author would like to especially thank Celia Clarke of the Portsmouth Society, whose numerous emails offered information, suggestions and downloads of her own very useful and interesting publications; John Stedman, also from the Portsmouth Society, again for advice and suggestions; the staff at the Portsmouth Central Library History Centre, all of whom were extremely helpful and supportive; the library staff at Fareham, who have an excellent local history section. My gratitude also to Denise Long, who first mentioned Byculla House. I would like also to thank the receptionists at University House and the University Information Centre; John Sadden, the archivist at Portsmouth Grammar School; Andrew and Revd Mike Duff of St Jude's, but *especially* David Cain, Portsmouth diocese executive assistant, and Sue Rau, for their time and patience in my enquiries concerning the height of the church steeple; the members of the City of

Portsmouth Preserved Transport Depot I met at Stokes Bay, and especially Paul Knight, for info on the Highland Road bus depot.

In addition there are a number of websites. For Given Celia's unstinting help, I would like to recommend the Portsmouth Society (www.portsmouthsociety. org.uk). Among others, I consulted Wikipedia, Lost Pubs of Portsmouth, Theatre Royal Heritage section and Hampshire Constabulary History Society. Again I would like to acknowledge the Alan Godfrey Old Ordnance Survey Maps for Old Portsmouth, Central Portsmouth, North End, Portsea, Southsea Eastney & Milton, dated 1896, which give a delightful insight into the city from that time. Likewise, the www.historyinportsmouth.com 'High Street in 1860' website, modelled by Southsea-based Tim Backhouse, also includes many interesting articles concerning the old town.

All photographs were taken by, and are the property of, the author. All opinions and comments expressed, and any unintended errors within the text, are entirely those of the author.

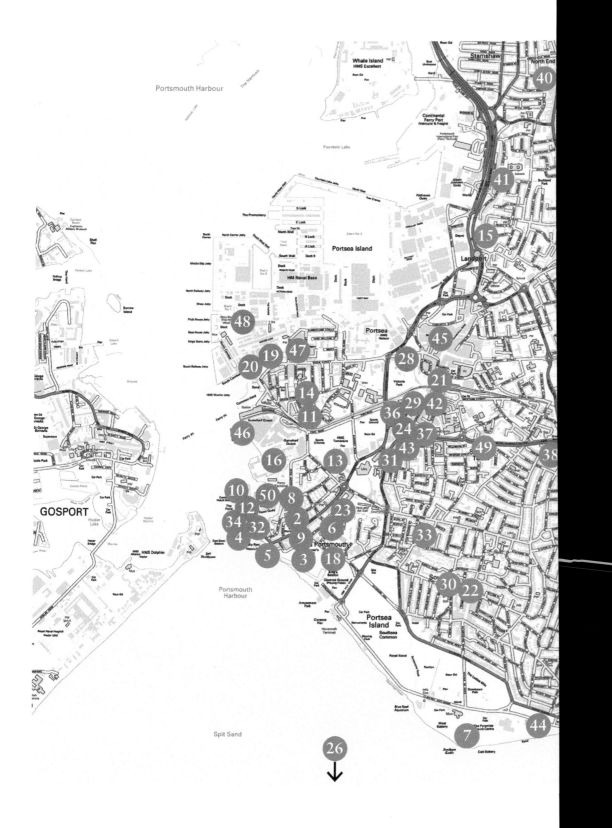

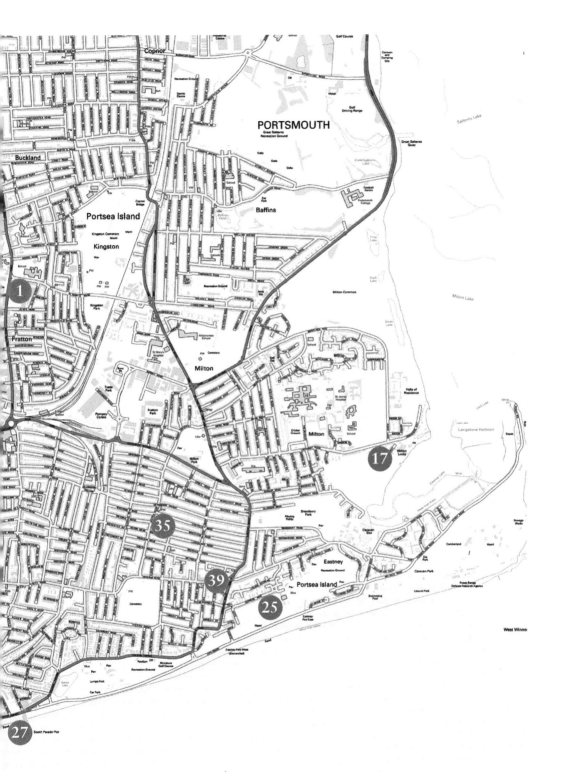

Key

1. St Mary's Church, Fratton Road, Portsea, *c.* 1170
2. Cathedral Church of St Thomas of Canterbury, High Street, 1188
3. Royal Garrison Church, Penny Street/Grand Parade, *c.* 1212
4. Round Tower, Point, Old Portsmouth, *c.* 1416–22
5. Square Tower, Broad Street, Old Portsmouth, 1494
6. Buckingham House, No. 11 High Street, 1527
7. Southsea Castle, Clarence Esplanade, 1544
8. Lombard Street, Old Town, *c.* 1625
9. The Dolphin Public House, High Street, 1716
10. Still & West Country House, Bath Square, *c.* 1730
11. St George's Church, St George's Square, Portsea, 1753
12. Quebec House, Bath Square, 1754
13. Landport Gate, St George's Road, 1760
14. Old Beneficial School, now Groundlings Theatre, Kent Street, 1784
15. Charles Dickens' Birthplace Museum, No. 393 Old Commercial Road, *c.* 1806
16. Vulcan Building, Gunwharf Quays, 1811–14
17. Old Engine and Pump House, Locksway Road, Milton, *c.* 1820
18. Former Guardhouse, Pembroke Road, *c.* 1834
19 & 20. No. 6 Boathouse, 1843, & Boathouse No. 4 Naval Dockyard, 1939
21. Portsmouth and Southsea Railway Station, 1847
22. Cambridge Barracks, now Portsmouth Grammer School, High Street, 1856
23. New Theatre Royal, Commercial Road, 1856
24. Former Royal Marine Barracks, Eastney, 1862
25. Spit Bank Fort, the Solent, 1861
26. St Jude's Church, Southsea, 1862
27. South Parade Pier, Southsea, 1879, Rebuilt 1908
28. Catholic Cathedral of St John the Evangelist, 1882
29. Town Hall, Later Guildhall, Guildhall Square, 1890
30. Byculla House, Queen's Crescent, Southsea, 1895
31. Former Pearl Building, Commercial Road, now Charter House, Lord Montgomery Way, 1899
32. The Seagull, No. 13 Broad Street, Point, 1900
33. The Clock Tower, No. 44 Castle Road, Southsea, *c.* 1903
34. Tower House, Tower Street, Point, 1906
35. The Former St Patrick's Chapel, Eastfield Road, 1906
36. Park Building, Former Municipal College, King Henry I Street, 1908

37. The Former Palace Cinema, now the Astoria Nightclub, Guildhall Walk, 1921
38. The Former Plaza Cinema, Victoria Road North, 1928
39. Former Portsmouth Corporation Transport Head Office, now Southsea Police Station, Highland Road, 1932
40. St Mark's Church, Derby Road, North End, 1970
41. 'Bucklands Wall', Grafton Street/Estella Road, 1972
42. Civic Centre Complex, Guildhall Square, 1976
43. Former Churchill House, now University House, Winston Churchill Avenue, 1986
44. Pyramids Centre, Southsea, 1988
45. Cascades Shopping Mall, Commercial Road, 1989
46. Emirates Spinnaker Tower, Gunwharf Quays, 2005
47. Admiralty Tower, Queen Street, 2008
48. Mary Rose Museum, 2013, Finished 2016
49. Somers Town Centre, aka 'The Hub', Straddling Winston Churchill Avenue, 2014
50. Land Rover Ben Ainslie Racing Centre, Camber Quay, 2015

The 50 Buildings

The Portsea village of Fratton predates Portsmouth by many centuries. The origin of the name is the Anglo-Saxon 'Froddaingtun', meaning the 'farm (or village) of Froda or Frodda'. In 1086 it was called Frodintone, and it was often called Frodington or Fraddington until at least the end of the seventeenth century, while the more modern spelling is known to have appeared on a document dated 1716. It is very likely that there existed an earlier church on the site now occupied by St Mary's, on the corner of St Mary's Road (once known locally as Dead Man's Lane because of the graveyard) and Fratton Road, perhaps from as early as AD 650 and certainly by the ninth century. However, our knowledge of the medieval church dates from either 1164 or 1170 when, 'for the safety of his soul', Baldwin de Portesia

> gave and granted to the Church of St Mary's, of Southwick, and the canons of the same, in free, pure, and perpetual alms, the Church of Portsea, with the lands, and tithes, and all things belonging to it, [together] with half a hide of land in Stubinton ... and pasture for 100 sheep, 15 beasts, and [either 50 or 20; there are two conflicting accounts] hogs.

This comparatively modest church building survived apparently 'with little alteration except the provision of an outside stairway to the gallery and a square tower at the west front' (William G. Gates, *The Portsmouth That Has Passed*) until a new, bigger building was erected in 1841, designed by Thomas Ellis Owen, the architect and developer responsible for much of Victorian Southsea and who also designed St Jude's, Southsea. However, to quote William Gates again, this building had 'nothing to distinguish it and the interior was of a most depressing character ... lacking in light or ventilation [while] many of the congregation could not even see the east end of the church or the preacher'. Another oddity was that Owen retained the old squat square medieval tower, tacking it onto the new taller west front. Illustrations for both the old medieval and early Victorian churches (the former a watercolour by R. H. C. Ubsdell, 1842) can be seen in Sarah Quail and John Stedman's *Images of Portsmouth*. Finally, at the instigation of the then vicar, Canon Edgar Jacob, the current, very grand, typically late Victorian Perpendicular-style church was constructed in 1887–89, designed by Sir Arthur William Bomfield (1829–99), himself the son of a bishop and a prolific church builder (his Wikipedia entry lists more than sixty ecclesiastical projects), but which David W. Lloyd

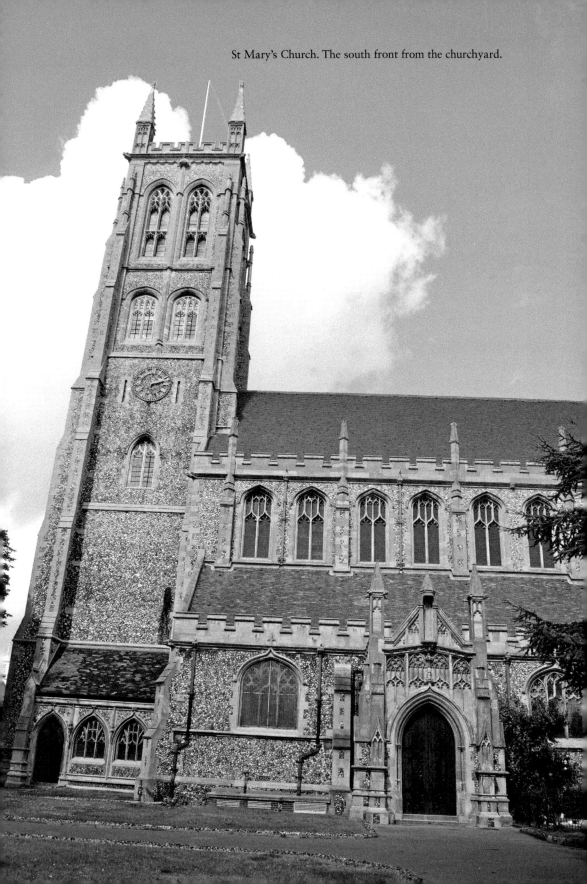

St Mary's Church. The south front from the churchyard.

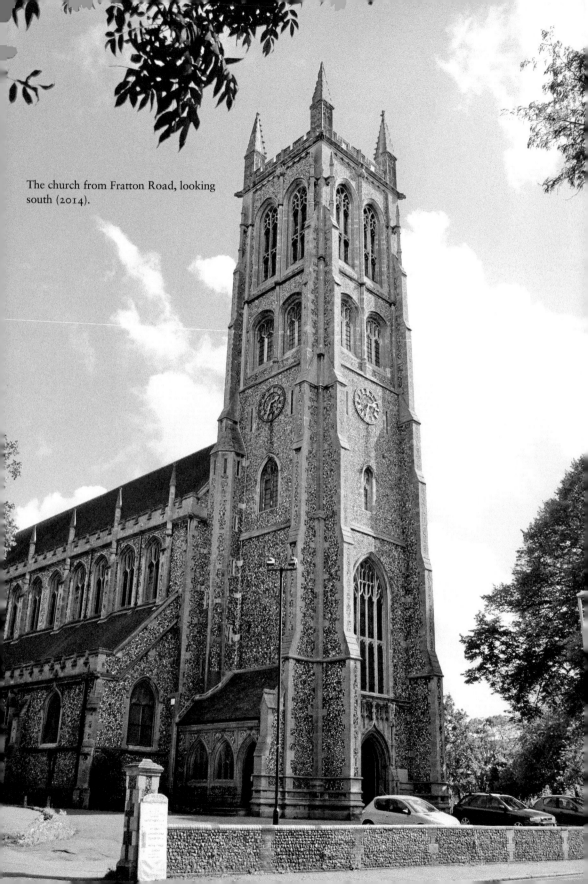

The church from Fratton Road, looking south (2014).

believes is his *tour-de-force*. John Offord called it a 'Victorian masterpiece, in a style inspired by the fifteenth-century churches of Norfolk and Suffolk'. The tower is 165 feet high, and was built to support a spire. Sir Arthur's son, Sir Reginald Blomfield, designed the Church Institute (Glebe Hall) opposite at No. 247 Fratton Road in 1899–1907. Following a chance meeting with Canon Jacob, over half the cost of the new church was generously contributed by the book and newsagent magnate W. H. Smith (1825–91), former First Lord of the Admiralty, later Viscount Hambleden (but after the village in Buckinghamshire, not Hampshire).

2. Cathedral Church of St Thomas of Canterbury, High Street, 1188

Like Portsmouth town itself, the former parish church dedicated to St Thomas à Becket owes its existence to merchant benefactor Jean (John) de Gisors, who, sometime between 1180 and 1187, founded a chapel to serve the emergent seaport, but – as with St Mary's – under the patronage of the Southwick Priory, only passing to Winchester College in 1543. David W. Lloyd (1974) says the church was under construction in 1185 and that part – probably, he suggested, the eastern end – was consecrated by the then Bishop of Winchester, Richard of Ilchester, in 1188, while the transept altars and churchyard date from 1196. The latter, with its picturesque jumble of gravestones, continued to be used until 1865, while further work to the sanctuary and transepts was undertaken in around 1190–1220. Built originally on a cruciform plan with a low central tower at the crossing, it officially became Portsmouth's parish church in 1320.

Cathedral Church of St Thomas, viewed from Oyster Street.

Above: The cathedral church, viewed from High Street (2015).

Below: The interior of the cathedral church.

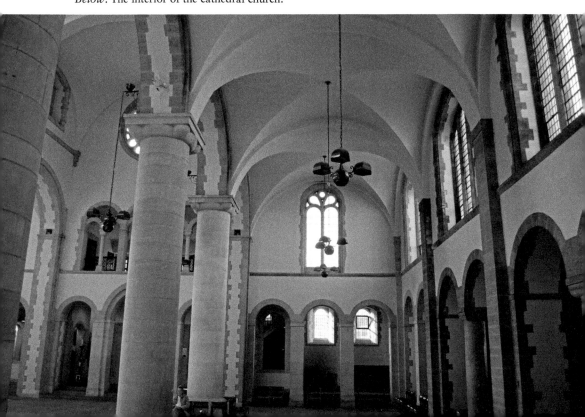

However, even after the Dissolution of the Monasteries in 1540, it often lived in the ecclesiastical shadow of the Domus Dei, the partial remains of what is now the Royal Garrison Church. In 1642 the tower was being used as a lookout by the Royalist garrison, and the church was targeted by Parliamentary gunners in Gosport. Twenty years after the Restoration, the patched-up tower and nave were in such danger of collapse that the congregation were forced to decamp to the Domus Dei. Only in 1683 did Charles II authorise the licensing of a national collection to raise the £9,000 needed to build a new tower (in 1691, of Portland stone, from plans by John Michell), and rebuild the nave and reroof the transepts, a task taken on after Michell by local carpenter Ambrose Stanyford from 1691 until his death in 1693. The octagonal wooden cupola was added in 1702/3 and the gilt-copper weathervane in 1710, replaced in 1954 when the original was blown down in a storm. As the congregation grew, galleries were built in 1706–08 and again around 1750.

In 1902 structural problems and effluvia from tombs inside the church posed a health and safety hazard and the building was closed until 1904. In 1927, the independent Anglican diocese of Portsmouth was created, partitioned off from Winchester and, essentially because of its historical associations, location and surviving medieval chancel, St Thomas was chosen as the new cathedral church. The vicar (later archdeacon) Neville Lovett (1869–1951) was elevated as its first bishop in October that year, a position he held until 1936. The old church was deemed too small and in 1933 Sir Charles Nicolson (1867–1949) was commissioned to extend it to a more cathedral-like dimension. His estimated £75,000 plan, published a year later, included a 150-foot Italianate campanile, but, while three new bays to the nave were constructed in 1935–39, work stopped with the outbreak of the Second World War.

Although it was made a Grade I-listed building in 1953, it was not until 1960 that new plans were put forward by John Seeley, 2nd Lord Mottistone (1899–1963), and his partner, Paul Paget. It would have been all glass, three-tiered and U-shaped, elegant and modern, but a lack of sufficient funds meant nothing happened until the late 1980s when the 1940 'temporary' brick west wall became unstable. Eventually work was finally completed in 1990–91 by Michael Drury, less ambitious in size although still costing £3 million. But while the interior is interesting and quite impressive, the overall exterior is now perhaps a rather inharmonious mishmash of different periods and conflicting styles.

3. Royal Garrison Church, Grand Parade, c. 1212

The Hospital of St John and St Nicholas (appropriately the patron saint of sailors), also known originally as God's House, or Domus Dei, was founded around 1212 by the Bishop of Winchester, Peter des Rouches, for the relief of travellers, the aged and sick, and it originally comprised a hospice and chapel, located on what later became known as Governor's Green. Although it closed in 1540 after the

Dissolution of the Monasteries, the chapel itself continued to retain its religious use, and Charles II married his Portuguese bride Catherine de Braganza here in 1662. The hospice buildings were used as an armoury before becoming the residence of the town's military governor, only to be eventually demolished in 1826. Town governorship was abolished in 1834, its last occupant being Prince William Frederick of Gloucester (1776–1834, governor from 1827).

However, decline and disrepair followed and by the nineteenth century it had been truncated at the west end, its windows altered, the roof replaced, and much of the medieval detail was lost beneath paint and plaster. In 1861 the architect George Edmund Street (1824–81) was commissioned to renovate the chapel into the Royal Garrison Church, this work being carried out in 1866–68. While he revealed and restored features concealed or lost, he also gave the church a typically non-medieval, Victorian appearance. The Grand Parade was bigger originally, extending between the church and the Long Curtain. On the 10 January 1941 incendiary bombs and high explosives left the nave roofless and the stained-glass windows destroyed, leaving only the chancel and church walls standing. New glazing was undertaken in 1947 and the 1980s, and the aisles were reroofed with slate in 1994–95, but the nave is still open to the sky. The church was Grade II listed in 1999 and is now maintained by English Heritage.

Royal Garrison Church. The ruined front from Grand Parade.

Inset: The font in the open interior (2015).

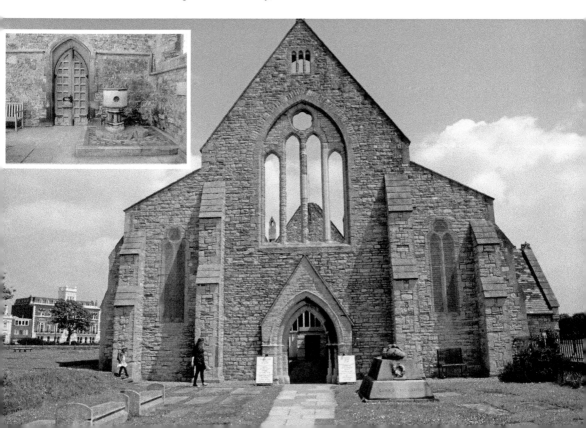

4. Round Tower, Point, Old Portsmouth, *c.* 1416–22

During the Hundred Years War several extremely destructive retaliatory raids were made against Portsmouth by the French – in 1338, 1369, 1377 and 1380 – eventually prompting a commission to survey the town in 1386, with the intention to improve its defences. Finally, during the reign of Henry V (1386–1422) the construction of a wooden round tower on the narrow gravel spit known as Point was began in 1416–22, supervised first by Robert Rodyngton and later by clerk of the works Robert Barbot, who spent the sum of £1,069 9s 8½*d* on this and a wharf on the Gosport shore, where he proposed another tower (where Fort Blockhouse is now) and extending an iron chain across the harbour mouth. The initial purpose was to protect ships anchored in the Camber rather than defend the town, but eventually, over the subsequent centuries, this humble beginning evolved into ever more complex defences, culminating in the nineteenth century when Portsmouth was the most heavily fortified town in the country, ringed by forts from Stokes Bay to Fareham, to Ports Down, and Fort Cumberland and Lumps Fort at Eastney.

The Round Tower was rebuilt in stone in the 1490s, and a defensive bulwark constructed between it and the Square Tower. Although the date 1495/6 is

The Round Tower, from Broad Street (old barracks), 2016.

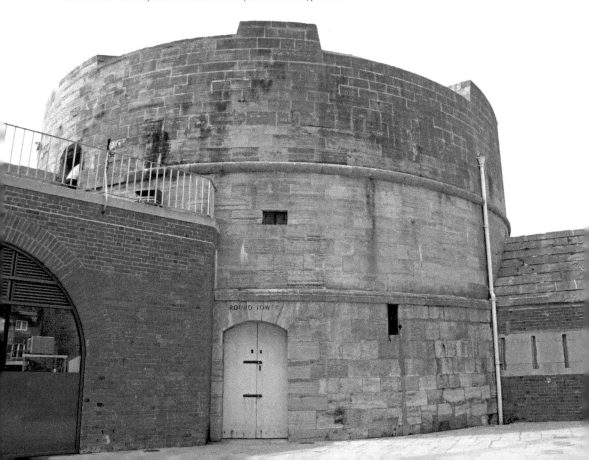

usually attributed to the founding of the dockyard when Henry VII ordered the building of a dry dock (near where HMS *Victory* is now located), there is evidence for offices, a storehouse and a forge already on site. In 1536 the tower was known as 'Master Ridley's Tower' after John Ridley, who was in charge of the town's royal buildings.

During the reign of Elizabeth I it was again rebuilt with six gun ports for cannons (three since filled in), but even then the tower was at risk of being undermined by the sea, and ships were often obliged to deposit a boatload of stones at its base. It was heightened during the Napoleonic Wars and again in 1850, and, apart from its Tudor base, much of the tower we see today dates from the early to mid-nineteenth century. The roof, now permanently open to the public, was a gun platform in 1847–50. The boom across the harbour mouth, controlled from Capstan Square, was in use until the Second World War, although William G. Gates wrote that early in the twentieth century the navy deliberately drove a torpedo boat at and over the then boom quite successfully without any damage to the boat. The tower was purchased by Portsmouth City Council in 1958 and was Grade I listed in 1969. It was converted for use as an exhibition gallery in 2011, and the entire area behind the sea walls, once occupied by the Victorian Point Battery Barracks, has been extensively renovated in 2016.

The Round Tower from Capstan Square, 2016.

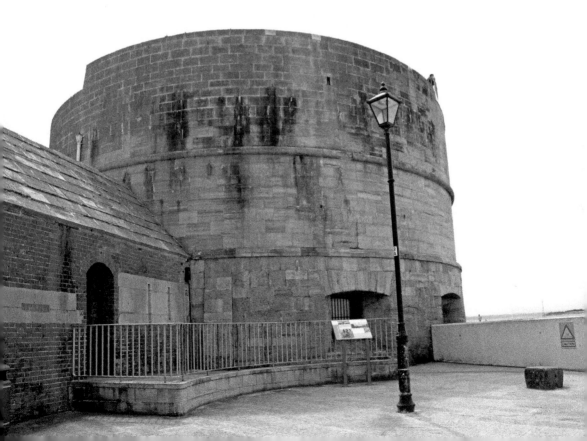

5. Square Tower, Broad Street, 1494

The Square Tower, located at the southern end of the High Street, dates from 1494, belonging as it does to the second phase of fortifications under Henry VII (1457–1509), and was the governor's residence until that was moved to the Domus Dei – the architect was believed to be Richard Shirborne. From 1584 it was used as a gunpowder store, and it was during the Siege of Portsmouth in August and September 1642 of the English Civil War that the then governor of Portsmouth, the 'dissolute and insubordinate' Colonel George Goring (also known as Lord Goring, the son of the 1st Earl of Norwich, 1608–57), threatened to blow up all 1,200 barrels of gunpowder – a foolish, impetuous act which could have destroyed half of the town and killed hundreds of civilians – unless the Parliamentary forces allowed him and his Royalist fellow officers to embark on a ship bound for the safety of Holland. The story goes that Goring held onto the key to the magazine and threw it into the harbour as they sailed away, and it was not recovered until the 1850s, after which it was displayed in the local museum.

In 1779 the tower became a meat store for the Royal Navy until that was moved to Priddy's Hard, Gosport, in 1850. In 1827 the Tudor exterior walls were resurfaced with Purbeck stone, and brick walls and vaulting were added internally. From 1823 a wooden semaphore tower was built on the roof, the first in the communication chain linking Portsmouth to London, but this was discontinued

The Square Tower being renovated, 1997. The notice was for the bicentenary of Australia's founding fleet event.

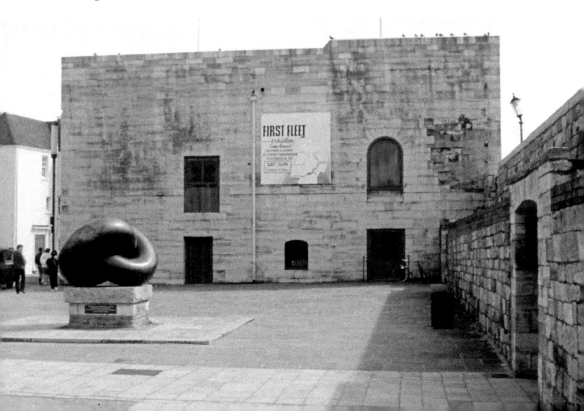

in 1848 when the electric telegraph made it redundant. In 1848–50 the tower was strengthened to carry three 8-inch heavy guns on the roof. It continued to be used for defence in both world wars, and later by the sea scouts and harbour pilots, before being purchased by Portsmouth City Council in 1958–60 and restored to its present condition in 1979–86. The bust in its niche facing Broad Street commemorates the return of Charles I 'after his travels through France and Spain', although the original gilded-lead statue, by sculptor Hubrecht (or Hubert) le Sueur (*c.* 1580–1656) and dated from 1635, is now in the City Museum.

In the early eighteenth century a pier was built where Victoria Pier is now, at one time known as Powder Bridge and then the Beef Stage. A new pier was built and opened in 1842 named after the queen, and was the landing place used by steamers to and from Ryde and Gosport, as well as a favourite promenade. It was washed away in a storm in 1925 and rebuilt five years later, opening in 1931. The tower is now used as tearooms, a market for arts and crafts, and a venue for weddings, christenings and funerals.

6. Buckingham House, No. 11 High Street, 1527

Now named Buckingham House, located just down from the grammar school, this is reputed to be one of the oldest, and perhaps most notorious, buildings in Old Portsmouth, being best known for where George Villiers, 1st Duke of Buckingham (b. 1592), was assassinated in 1628. As a courtier and favourite – some say lover – of James I (1566–1625), he was made Viscount Villiers, Knight of the Garter and Gentleman of the Bedchamber in 1616, Marquis of Buckingham in 1618, and Lord Admiral of the Fleet in 1619. He had considerable – again, some might say disastrous – influence over James and later Charles I, and subsequently a series of political and military adventures by him resulted in failure and charges of incompetence. On 23 August 1628 Villiers, together with his wife, the former Lady Katherine Manners, and his sister, the Duchess of Denbigh, were staying here with Captain John Mason, one time Governor of Newfoundland, when he was fatally stabbed by John Felton, an embittered army officer from one of the duke's campaigns who was probably suffering what we would now call post-traumatic stress disorder. Felton was afterwards regarded by many as a virtuous Protestant hero who (in the words of Sir John Oglander) had 'rid ye commonwealthe of a monster', and following his execution at Tyburn in November, his body was bought back to Portsmouth, intended as a deterrent, but instead became a source of veneration.

Long before Villiers' assassination, the building had been a hostelry, first recorded in 1527 as 'le Greyhounde', licensed as 'a brewery, granary and garden'. It was rebuilt not long after and in 1544 was the home of John Chadderton. Before 1628 it was still known as the Greyhound pub, but also as 'The Spotted Dog'. Although most sources still referred to it being a pub or inn, at least one states that Captain Mason had purchased the property in 1626. Certainly it would seem major rebuilding was undertaken in 1627, and in 1700 the adjacent building (now No. 11)

Buckingham House, 2016.

was incorporated then refronted, and internal alterations were made in 1705 when it was purchased by Dr William Smith, who founded the nearby grammar school.

In 1760 part of the house was demolished for the building of No. 10, and in 1800 it had been divided into two units, Nos 10½ and 11. Later, in 1818, work undertaken by Revd George Cuthert (1749–1826, whose father, also George, was once physician to the garrison) destroyed forever the symmetry of the street façade. By the 1870s the bricks were rendered and covered in limewash. In 1941 it suffered bomb damage, No. 11 becoming derelict until 1947 when local architect R. A. Thomas acquired the property and made restorations, exposing, and thereby preserving, many of the original features including the Tudor panelling in the Red Room. It was Grade II listed in 1953. Although listed as being 'late eighteenth century', David W. Lloyd wrote it 'is basically a sixteenth-century timber-framed structure, altered externally, and added to, in Georgian times'. There is now a plaque on the street wall commemorating the Duke of Buckingham's assassination.

7. Southsea Castle, Clarence Esplanade, 1544

In 1538 the usual threat of war with both France and Spain prompted Henry VIII to build a series of castles and forts from Deal, Warmer and Sandgate in Kent to Dorset and St Mawes and Pendennis in Cornwall. In the Solent region, forts

were built at Cowes, Hurst Castle near Lymington, Yarmouth on the Isle of Wight, Calshot and Netley Castles to defend Southampton, and in 1538–44 Southsea Castle was constructed to protect the approach to Portsmouth Harbour. This Tudor castle, on wild and marshy common land, was built by Sir Antony Knyvet, then governor of Portsmouth, the master mason being Thomas Bertie. It comprised a small square central keep (much of whose stone walls have survived, although the original gun ports mostly blocked off) within a low-walled enclosure and with raised gun platforms to the east and west. It cost £3,100, a third of which was raised from the Dissolution of Monasteries. Later, a glacis, or outer earthwork, was constructed by Dutch-born Sir Bernard de Gromme during the reign of Charles II, and it is the king's arms, dating from 1683, that we still see over the main entrance. It has to be said that both these designs, as well as work undertaken elsewhere on the town fortifications started by de Gromme in 1665, were all at the very cutting edge of military engineering for their time.

Having seen action in the English Civil War, and again briefly in the so-called Glorious Revolution of 1688, the eighteenth century saw a period of neglect. In 1759 a deadly gunpowder explosion damaged the east side, and by the second half of the century it was reported that the garrison comprised 'an old sergeant and three or four men who sell cakes and ale', while by the late 1700s coastal erosion had destroyed the grand battery. Only in 1797, with a renewed threat of French invasion, was the castle again subject to renovation and redesign from

A view of the entrance gate of Southsea Castle (2015–16).

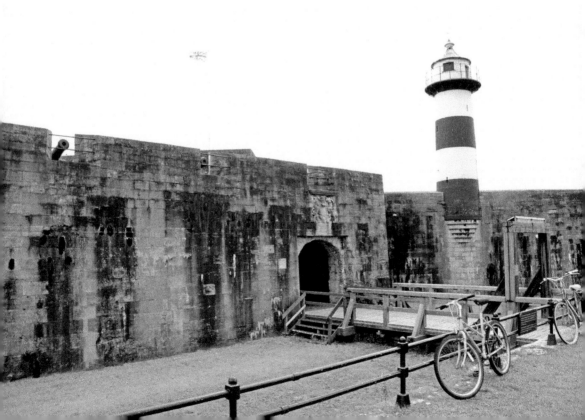

1813 to 1816, initially under the direction of Major-General Benjamin Fisher (1753–1814) of the Royal Engineers, who had at one time been commanding engineer in Quebec, Canada. The castle was enlarged with new brickwork to the keep and bailey, and the counterscarp gallery was built. The cost was £18,105, not an inconsiderable sum for that time. In 1828, by orders of the Admiralty, a lighthouse was constructed, 34 feet (10m) above its base on the west gun platform. It is still used but is now automated. The government took possession of the common in 1785 to ensure it remained open and accessible to the fort's guns, and the marsh, known as the Great and Little Morass, was systematically filled in by convict labour from 1831 onwards. Within ten years private housing was built on the northern edge, at first for military and naval officers.

From 1844 to 1850 the castle was a military prison, before undergoing major structural alterations reflecting the changes and advances in defensive and offensive weaponry. Portsmouth Corporation leased the common in 1884, planting trees and laying out paths including the Ladies Mile, only eventually purchasing it from the War Office in 1922 for £45,000, when it was finally designated a public park. By the late 1890s/early twentieth century the fort was again considered militarily obsolete, although searchlights, quick-firing guns, and (in both world wars) anti-aircraft guns were stationed there, manned by Royal Artillery Volunteers, TA units, or the Home Guard. In 1940 the castle guns were briefly involved in a confrontational stand-off with French naval vessels in Portsmouth Harbour, with

The interior courtyard (2015–16).

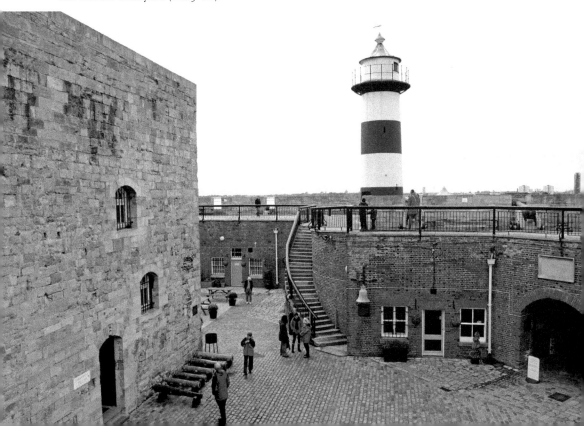

the French destroyer *Léopard* threatening retaliation. After the castle was sold to the city council in 1960 for £35,000, the east and west batteries were partly demolished and castle restored to its pre-1850 appearance, opening in 1967 as a museum. The nearby D-Day Museum was opened in 1984 by Elizabeth, the Queen Mother. The aptly named Courtyard Café was opened in 2015.

8. Lombard Street, Old Town, *c*. 1625

Sadly so little of Old Portsmouth survived the devastation of 1940–41, or the post-war rebuilding by modernist town planners intent on the opportunity to sweep away the old, that the few buildings we *do* still see in and around the High Street and Broad Street are to be doubly enjoyed and appreciated for what has been preserved and what was lost. White Hart Road and Oyster Street are lost to us, but some parts of St Thomas's Street remain, and also some of Lombard Street. Here Nos 7–15 are either late to mid-eighteenth century, Nos 7 and 9 (Powderham House and Lombard House respectively, both Grade II listed) being very typically Georgian – three storey with a square street façade, made of grey and red Flemish bond brick and oriel windows on the first floor and interesting

Lombard Street, viewed in 2016.

Inset: A late 1970s view from Lombard Court.

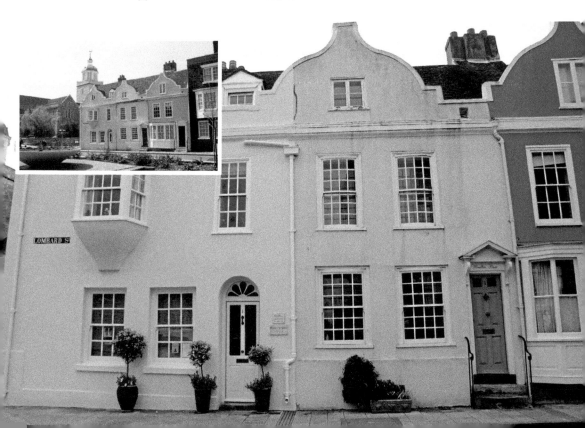

doorways. Nos 1–5, however, come as a complete contrast in style and quite delightful in appearance. Although separate dwellings, they comprise a single harmonious unity with their unusual, but elegant double-curved Dutch gables, and stucco colour-washed plaster. No. 5 is known as Trinconalee and No. 3 as Hamilton House. All are Grade II listed (since 1953) but, although most sources state they are mid to late seventeenth century, it is quite possible that behind the current façade is a much older, possibly timber-framed structure. This is perhaps why No. 1, the larger corner property with its upstairs bow window, has a plaque that reads, 'Ruby House 1 Lombard Street – formerly The Ruby Pub *c.* 1850-1923 – Now 'Many Cargoes' – circa 1625.'

Also known as the Ruby Inn in *Kelly's Directory*, it was listed as a 'beer retailer' until 1925, but Peter Rogers states in the years 1932–34 it was a Youth Hostel Association hostel for women – men apparently being accommodated at the YMCA in the High Street. All three properties have been exclusively residential since the 1930s. The distinctive gables may possibly be due to Dutch military engineers in the seventeenth century who added the first floors. The stucco work was a later addition.

9. The Dolphin, High Street, 1716

Competing with the nearby Still & West for the status of Portsmouth's oldest public house, the Dolphin is one of only a few buildings in the lower High Street to have survived the destruction of the Second World War. Ron Brown says it was formerly known as The Maidenhead, only later as the Dolphin Inn or Hotel, and local historian Stephen Pomeroy dates the granting of the first licence to sell alcohol to 1716, and this, together with the words 'Portsmouth's Oldest Pub', is the date proudly displayed on the street façade. David W. Lloyds remarks that the Dolphin was another example of having 'timber framework behind their Georgian façades', and could, therefore, be older than they appear. While some minor exterior details have altered over the years, it is still surprisingly recognisable to the Charpentier illustrations of the High Street in 1842.

Records show it was owned by Andrew Player prior to 1802, when Charles Thomas Jr took over. It was sold by auction in 1840, as a 'well accustomed, highly respectable freehold inn and tavern – most advantageously placed' said the *Hampshire Telegraph* (quoted from Tim Backhouse, *History in Portsmouth*). From around 1859 and throughout the 1860s the landlord was listed as William Bond, in the 1861 census aged forty-four, victualler, with his wife Caroline, six children and three lodgers. During this time it was licensed for entertainment ('songs, bands, ballet') but Bond was also listed as the owner of 'American Bowling Alleys and Billiard Rooms'. In 1914 the occupants were James and Grace Innes, whose son Henry Pembroke Innes was killed in May 1918, aged thirty-nine.

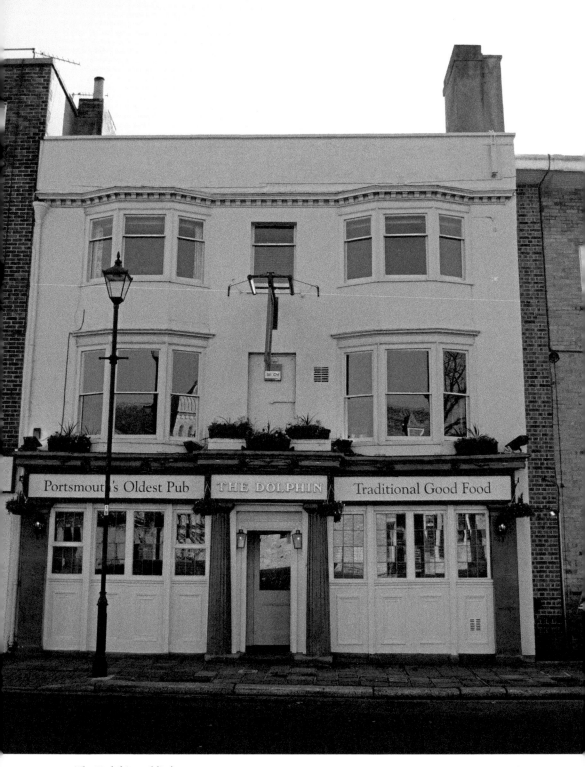

The Dolphin public house, 2015.

Somehow the interior too has more or less survived the intrusive remodelling so beloved by brewery chains, but it was threatened with closure (for hygiene reasons) in 2013, and again in March 2016 following a 25 per cent rent hike by owners Enterprise Inns. It reopened in May 2016 following a £150,000 revamp, but is now part of the Bermondsey Pub group, an Enterprise Inns spin-off.

10. Still & West Country House, Bath Square, c. 1730

On the front façade of what is now the Still & West Country House pub is the date 'c. 1700', but the earliest record of the Still Tavern (as it originally was) being licensed is around 1730 – Ron Brown says 1733. While one explanation of the name connects it to 'the whistling 'The Still' with the boatswain's pipe', surely more likely is that it was a distillery brewing its own beer. In 1882 John Main of the Still Tavern married Elizabeth Long of the nearby East & West Country House, but it was only in 1903 that the pub acquire its present name, the brewery then being George Gale & Co. A contemporary photograph has the

Still & West Country House, viewed in 2015.

Inset: A late 1970s image of the pub, from Bath Square looking towards Point.

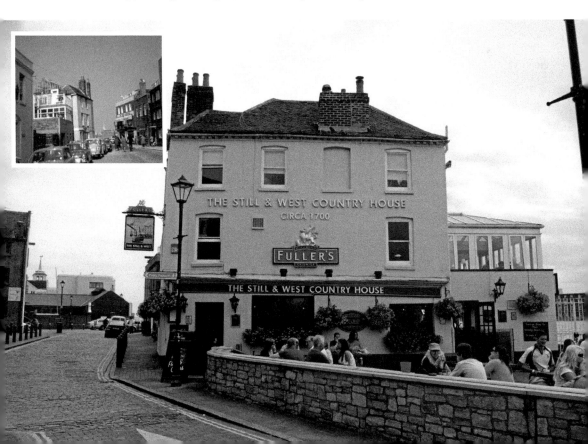

legend 'Estd.1711', as well as 'Licensed to open at 4 a.m.', this because there was then a busy daily fish market immediately in front of the building, facing what was then the Gosport chain-ferry, or 'floating bridge', which operated from 1840 until 1959.

In August 1960 the last Royal Navy battleship, HMS *Vanguard* (lion class, launched in 1944, commissioned in 1946, flagship of the commander-in-chief Home Fleet 1952–54, in reserve from 1956), was being towed out of Portsmouth Harbour for the last time under Lieutenant-Commander W. C. Frampton, on its way to the scrapyards at Faslane, when suddenly it skewed off course and headed straight towards the Still & West and the Custom House Pier. Disaster was only averted by the quick thinking and prompt action of the tow master, Harry Otley – the stunning aerial photograph of this event can still be seen in the pub's downstairs lounge.

It was Grade II listed in 1972 and is described as being 'late eighteenth century to early nineteenth century'. My earlier photograph, taken from Bath Square, dates from the late 1970s, before the building was extended to the rear. Instead there was a sort of two-storey conservatory on the back and what looked like a greenhouse on the roof!

11. St George's Church, St George's Square, Portsea, 1753

Until the late seventeenth century what is now called Portsea or Landport was farmland, with a large tidal inlet flowing in from the sea where the United Services Recreation Ground is now, and a sea mill that was used by townspeople to grind grain into flour. Up until that time the military authorities had forbid the construction of buildings 'without the walls', and indeed the 'pious and pitiless' lieutenant governor from 1689 to 1717, Sir John Gibson, also one of the town's two MPs, had once threatened to turn the garrison guns on anyone who dared 'lay one brick on another'. However, in 1703 Queen Anne finally granted permission for the dockyard shipwrights to build houses between the then still-walled Portsmouth Old Town and the dockyard itself, on what continued to be known as Portsmouth Common until 1792, when it thereafter officially became Portsea. In gratitude Queen Street is named after her. Within a hundred years, when the first census was taken in 1801, the population was already 24,327 compared to Portsmouth's 7,839.

The foundation stone for St George's Church, St George's Square, also known as the Shipwrights' Church, was laid in May 1753 by shipwright William Johnson. Probably designed by the dockyard surveyor in the New England colonial style, the construction was overseen by Nicholas Vass. It was built in fifteen months by fifteen shipwrights from the dockyard, who were also joined by 'three gentleman, one carpenter, one tallow chandler and one grocer', at a cost of £2,208. It became the parish church in 1875. Originally the square was funnel shaped, extending behind the church, where it became

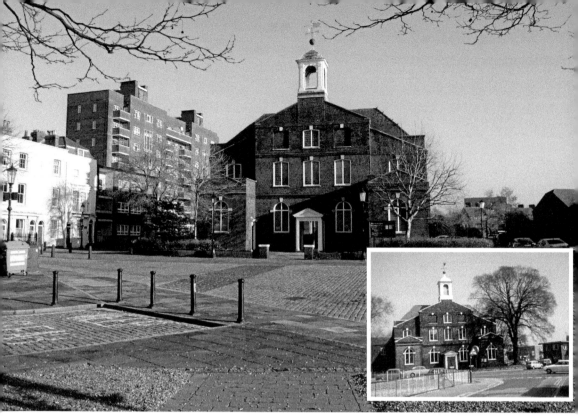

Above: St George's Church. A view of the front from St George's Square, Ordnance Row.

Above inset: A view from Ordnance Row in the late 1970s.

Below: A side view from Little Briton Street.

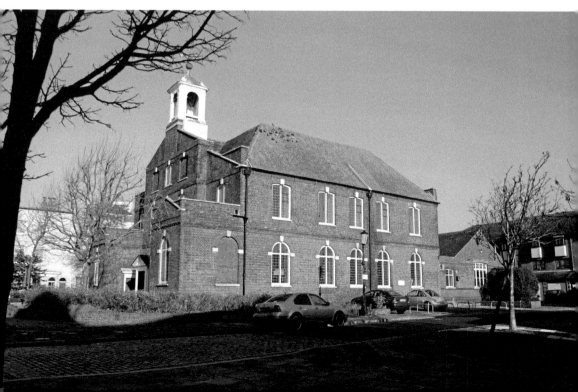

St George's Street only once it went passed the junction with Kent Street, with buildings facing onto Ordnance Row. During the Second World War many of these old seventeenth- and eighteenth-century buildings were lost, and the existing square was remodelled as a small public garden, where in 2006 a memorial was unveiled to the early Victorian engineer Isambard Kingdom Brunel (1806–59), who was born in nearby Britain Street. The church was badly damaged, remaining closed from 1941 to 1951, restoration only starting in 1952, with further work undertaken twenty years later. Sadly, despite its Grade II listing, it is again in a poor structural condition and applications have been made to the Heritage Lottery Fund. Although a terrace of original elegant buildings survive between Victory Road and Rosemary Lane, post-war rebuilding saw many of the surrounding street layouts completely change, with offices on the south (Britain Street) side and new residential blocks to the north. Most are modest in scale, except the awful twenty-storey Millgate House tower block, built in 1964.

12. Quebec House, Bath Square, 1754

Bath Square was originally named Bathing House Square, although it is not really a square, merely a short street widening briefly into what is now a permanent cobbled car park, before continuing as West Street, then Tower Street. Located between the old Custom's Watch House and the small boatyard (in the nineteenth century the site of the New York Tavern) is the white, wooden weatherboard, or 'clapboard', building known as Quebec House. This modest but delightful building was constructed on a brick platform facing onto the sea, perhaps one of the earliest examples of a sea-bathing establishment, and was built from public subscription of the local inhabitants and erected in 1754. Originally, four ground-floor baths of differing size and depth were connected to the sea via pipes, and, as the tide ran, they were flushed with fresh salt water. Apparently there were even separate changing rooms for men and women. Previous to this, it is said that one Joseph Bucknall had leased the beach on this spot, again for the purpose of bathing.

Early in the nineteenth century it became part of the Quebec Hotel (or Tavern), so named apparently because passenger ships for North America used to depart from here, although the website www.hampshire-history.com speculates it may have been so named to commemorate the 1759 Battle of Quebec. What we do know is that in June 1845 the hotel saw brief fame (or perhaps infamy) as where the last Englishman died from injuries sustained from an official duel, when 'Captain' James Alexander Seton of Fordingbridge, Hampshire, had fought, and was fatally wounded, in a pistol duel with Lieutenant Henry Hawkley of the Royal Marines several weeks earlier at Browndown Common, near Gosport. Contrary to many sources, Seton was *not* a serving officer, but a former cavalry commissioned officer with the rank

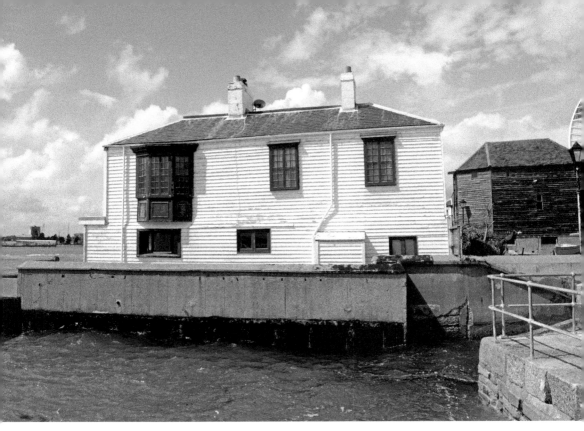

A side view of Quebec House, with Bath Square on right, 2015.

of cornet (abolished in 1871, the modern-day equivalent of second lieutenant), and, while staying at Southsea, had attempted to embark on an affair with Hawkley's wife Isabella, despite being there with his own wife Susanna, by whom he had a young daughter. Hawkley and his second, Royal Marine Lieutenant Charles Lawes Pym, were subsequently tried for murder in March 1846 at Winchester assizes, but were acquitted.

In the detailed 1860 OS map Quebec House is listed as a 'warehouse', and possibly later the ground floor may have been used as a shop. The building was Grade II listed in 1969 and has probably been in residential use now since the late nineteenth century onward.

13. Landport Gate, St George's Road, 176c

Portsmouth, Portsea and Gosport remained virtually unique in Britain in that (more like many major towns in continental Europe) they continued to be maintained and improved as fortified towns even after the English Civil War, right up until the second half of the nineteenth century. In the UK only Berwick-on-Tweed and Londonderry shared this distinction, but again Portsmouth is almost alone in having post-medieval neoclassical town gateways, of which only the Landport remains in situ, although this might not seem obvious at first. King James's Gate (1687), which

once divided the town from Point, was dismantled in the mid-1860s to 1870 and re-erected, first in St Michael's Road in 1881, opposite the then Registry Office, and only later, early in the twentieth century to its present site as entrance to the United Services Recreation Ground in Burnaby Road, although unfortunately by then much of the stonework of its pediment and turret was lost or stolen. Unicorn Gate (1778), one of two gateways to Portsea, which stood at the northern end of York Place, was re-erected in 1865 as one of entrances to the dockyard, while the Lion Gate (1770), formerly across Queen Street, was eventually incorporated into the structure of the Semaphore Tower in the dockyard in 1926–29.

Landport dates from 1760, and it was first suggested in the *Architectural Review* in 1952 that the design be posthumously attributed to the architect Nicholas Hawksmoor (1661–1736). When engineer Sir Bernard de Gomme remodelled the town's fortifications in the previous century, the original Landport at the top of the High Street was blocked off and a new gate was constructed to the north-west, opposite the end of Warblington Street. Thereafter, if approaching Portsmouth from the north, one had first to breach the glacis, then a drawbridge across a moat to the Landport Ravelin, then another bridge over the main moat to the gateway itself, located between Guy's Bastion on the right and Town Mount Bastion on the left. Immediately on the right as one entered the town was the Colewort Barracks, dating from 1694. Originally a military hospital occupied much of the walled-in area north of Warblington Street and

Landport Gate (2016).

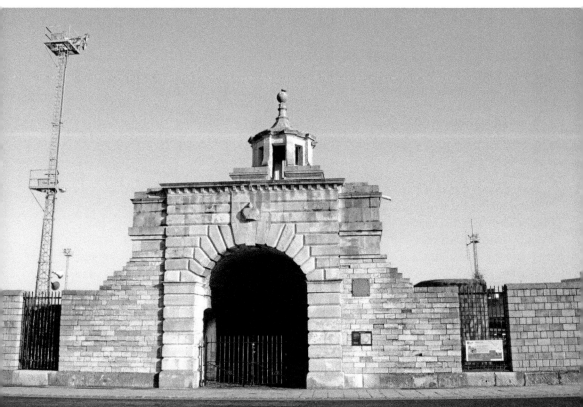

east of what at that time was known originally as Colewort Garden Street, later as St Mary's Street, finally Highbury Street. This was later the site of the town's coal-fired power station, constructed in 1892–94, and enlarged in 1927, when the chapel of St Mary of Clozse (built in 1839) was destroyed. The two 300-foot-high chimneys, together with the massive conveyor belts over Gunwharf Road from Camber Dock, dominated Portsmouth until it was decommissioned and in turn demolished in 1981–83. A car park and 1980s residential housing, the Gunwharf Gate estate, now occupies this site.

Finally in 1864 the old town was freed from its straitjacket of military fortifications. The Town Mount Bastion – whose grassy embankment and low walls, topped with elm trees, had long been a promenade across the top end of the High Street – was demolished, and thereafter Landport Gateway languished into isolation and disuse. With the exception of the Saluting Battery, Hot Walls, and the Long Curtain and its moat, the rest of the town walls were all cleared away by 1875, and new roads appeared in their stead – Gunwharf Road, St George's Road, Cambridge Road connecting with Commercial Road and, beyond that, London Road, what was soon to be the new heart of Portsmouth, and Alexandra Road, later renamed Museum Road. Rather sadly, this once important gateway is now just a decorative element to the south-west parameter of the United Services Recreation Ground, often obscured by rows of parked tourist coaches.

14. Old Beneficial School, now Groundlings Theatre, Kent Street, 1784

In his 1986 essay Laurence V. Gatt remarks how 'many people still refer to Portsmouth's famous Charity School as 'Old Benny' and 'think of it with affection'. In 1754 eight men of varied commercial backgrounds, from merchant to brewer, to grocer, apothecary, ironmonger, draper, butcher and carpenter, agreed to set up a mutual aid society, which they named the 'Beneficial Society', each contributing a monthly payment of 1s (12d) per month. In the spirit of the age of enlightenment and philanthropy, they agreed that any surplus 'be applied to the putting out poor Children to school which shall be chosen by ticket'. Initially six boys were selected to be taught under Charles Bettesworth, the first of thirteen schoolmasters from 1755 and 1939, when the school, having by then fallen under the Local Education Authority, was redesignated as a junior school. During that period of nearly two centuries some were strict disciplinarians, others innovative and reformers, while others were dismissed or – for various reasons – later resigning from their posts, but the school expanded and thrived, so much so that the pupils soon numbered twenty, prompting the next schoolmaster, William Cox, one of the society founders (and in his dual function as secretary), to oversee the purchase of a £280 plot of land in Old Rope Walk (now named Kent Street), nearly 32 feet by 70 feet, and the eventual construction in 1784 of the elegant two-storey Georgian building we see today. The school used the ground-floor open hall, while initially the society continued to use the upper rooms.

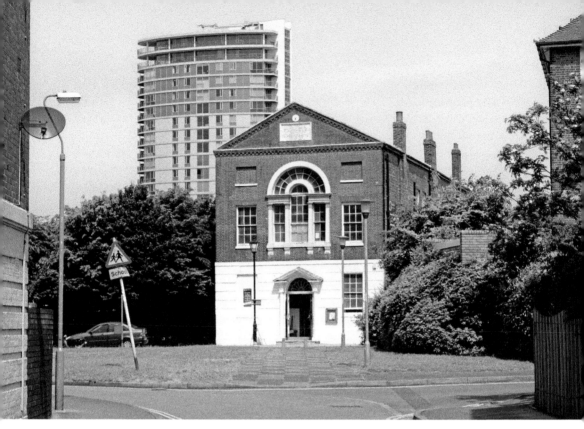

Old Beneficial School, viewed from across Kent Street.

In 1829 the society discussed the possibility of 'extending the Charity to poor Female Children', although the motive was as much on moral grounds of trying to prevent the girls from the 'low habits of vice and idleness' as their possible intellectual contribution to society. The original building was enlarged in 1836 and the Beneficial Girls' School opened in 1837 under Mrs Charlotte White, widow of William White, the headmaster of the boys' school from 1826 to 1829. Inevitably, overcrowding and sanitation became a problem, with a 1851 report by Dr Henry Slight detailing the boys' class room as 58 feet by 30 feet, the girls 34 feet by 30 feet, and 13 feet high, ventilated by six windows at the side and a large one at the end, but closely hemmed in by nearby buildings. He gave the then number of scholars as 240 boys and 180 girls. There was no playground, and study time was for seven hours daily, while the WC and privy was outside, emptying into a cesspool. Nevertheless, despite such conditions and harshness, the school was a success, with at least one old boy being Sir Henry Ayres, seven times premier of South Australia and after whom Ayres Rock was named in 1873, now also known by its aboriginal name *Uluru* since 2002.

The Beneficial Society was eventually dissolved in 1933, and the building ceased to be a school in 1962 when the new primary school was erected nearby. This in turn is now St George's Beneficial C. of E. Controlled Primary School located in Hanover Street. The building continued as a place of education, however, becoming a youth training centre until 2004 when it was badly damaged by a

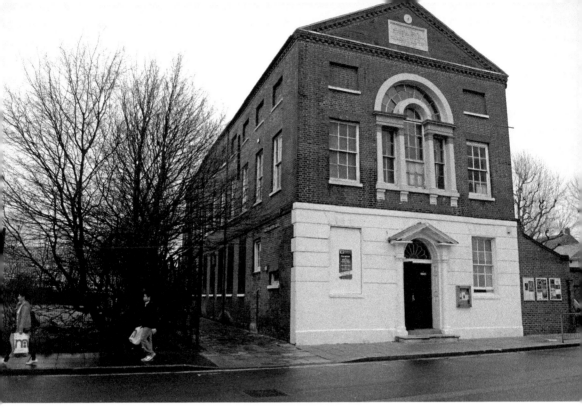

The school also viewed from Kent Street, with Southampton Row passageway on the left, 2015–16.

serious fire. In May 2010 it opened as Groundlings Theatre, a performing drama school set up with the aim to help adults and children audition and develop acting, dance and stagecraft. In addition to regular innovative theatrical performances, they have a tearoom/restaurant and a vast selection of period costume for hire, as well as being used by television and movie productions, and schools.

15. Charles Dickens' Birthplace Museum, No. 393 Old Commercial Road, c. 1806

Despite Portsmouth's best efforts to forever link the city with the famous Victorian writer and social critic Charles Dickens, in truth the connection was a rather brief affair. Newly married John Dickens (1785–1851) came here from London with his wife Elizabeth (née Barrow, 1789–1863) in 1809, having obtained a post in the Navy Pay Office in the dockyard. They moved to what was then No. 1 Mile End Terrace (one of four adjoining properties, so named because being a mile from the dock gate) and it was here that their son Charles, the second of eight children, was born on 7 February 1812. Apparently unable to afford the rent (£35 per annum) and to escape the rent collectors, in June the same year they moved, first to a small and cheaper property in Portsea and again later, still within the town but for the same reason, before eventually decamping to Rochester, Kent, in 1814. Thereafter

Dickens himself only briefly visited Portsmouth again in adulthood, ostensibly to give readings from his works, although rather coincidentally both his first real love, Maria Beadnell (later Mrs Winter, 1810–86), and his mistress-lover, Ellen Ternan (1839–1914), are buried at Highland Road Cemetery. Dickens himself died in 1870 at Gads Hill Place, Higham, Kent, and, contrary to his wish to be buried in Rochester Cathedral, he was laid to rest in Poet's Corner, Westminster Abbey.

The house where he was born, now No. 393 Old Commercial Road, was built around 1806 as a speculation by William Pearce, a solicitor who himself lived in the slightly more substantial house, now No. 391 (itself Grade II listed in 1972). Originally also called the Old London Road, the name was changed to Commercial Road in the mid-nineteenth century. Portsmouth Borough Council (as it then was) bought the house in 1903, and it has since been maintained as a museum dedicated to the writer. Even on 1898 OS map this district was referred to as the 'Charles Dickens Ward'. It was designated the Mile End Conservation Area in 1970, and the house itself (Grade I listed in 1953) was completely refurbished in 1969–70. With the busy new Mile End Road dual carriageway located immediately to the west, linking (from Rudmore Roundabout) with the M275, this is now a delightful oasis of preserved Georgian and Victorian urban townscape, complete with a limited stretch of embedded tramlines. The nearby chapel dates from 1884, while what is now No. 373 had once been the Mile End Cellars pub (George Gale Brewery) until 1977, when it was demolished and replaced by the Scottish & Newcastle-owned Oliver Twist pub from around 1979 until the beginning of this century. It is now the offices of a freight services company.

Charles Dickens' Birthplace Museum (2015).

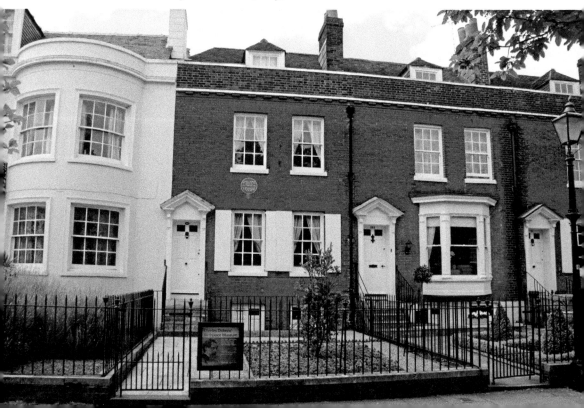

16. Vulcan Building, Gunwharf Quays, 1811–14

Prior to 1855, a ship's weaponry (heavy guns, small arms, even cutlasses) belonged, not to the Admiralty or Navy Board, but the Board of Ordnance, and their storage – both in readiness prior to ships going to war, or when sailing ships were in dry dock for maintenance and all the guns and ammunition needed to be unloaded or the weight caused damage to the wooden structure or keel – was completely independent from the Royal Dockyards. Tim Backhouse, in his article on the history of Gunwharf for the website www. historyinportsmouth.com, says construction of what later became 'Old Gun Wharf', reclaiming the mudflats north of the creek leading to the Mill Pond (where the United Services Sports Ground is now), started around 1700 onward. Even then it was intended essentially as a navy repository for guns, small arms and ordnance, and replacing an earlier wharf on the Point. Only in the 1770s was the decision taken to extend the original ordinance yard to the south of the creek, in effect doubling its size, again on reclaimed land, and this became known as 'New Gun Wharf', linked by a swing bridge across the creek canal, much as we still see today.

Vulcan Building, Gunwharf. The north side with early nineteenth-century walls.

Construction of New Gun Wharf began around 1797, initially continuing until 1814, and the original boundary can still be seen with the early nineteenth-century gateway opposite what is now the Vulcan Building, the Grand Storehouse as it was, the foundation stone for which was laid on the 28 November 1811 by Prince William, Duke of Clarence, later William IV (1765–1837). It was completed in 1814 and designated as the 'Land Service Store', similar in size to the 'Sea Service Store' on the Old Gun Wharf, although by the second half of the century there were over a dozen other storehouses on site, plus various workshops for specialist armourers, blacksmiths, coopers, carpenters, etc. The north wing and clock tower were destroyed in the Second World War and only reconstructed in the 1990s. Now a Grade II-listed building, it has been converted to residential use, with a restaurant and retail outlet on the ground floor. With the demolition of the old town fortifications, the new boundary wall was built in the 1870s, along with the still-impressive Victorian main Vernon Gate, facing onto St George's Road and Park Road.

Some of the storehouses were converted into barracks for the Royal Marine Artillery, who were based here from 1824 until 1858 when they moved out to Fort Cumberland, and later Eastney. With the abolition of the Ordnance Board in 1855, the War Office took over responsibility, and from 1888 Gunwharf was split between the army on the north side and the navy on the south, and it only fully reverted to Admiralty control in 1915 when the army relocated to Hilsea. In 1919 the southern half became the Mines School, the north half the Torpedo

A view from the south side (the clock tower and left-side wing rebuilt in the 1990s), 2016.

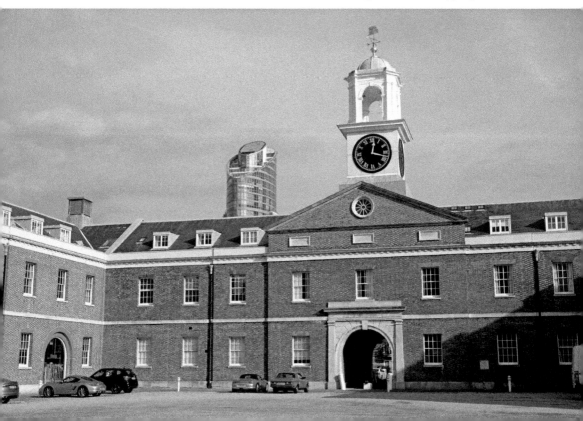

School, and a base for motor torpedo boats. In 1923 it became the shore-based HMS *Vernon*, then, following restructuring and mergers, becoming HMS *Nelson* in 1986–87 (although still known locally by its former name) until that too ceased operations in 1995. The MoD then sold the site for redevelopment in 1996 to the Berkeley Group, their plans being undertaken by HGP Architects. It opened as Gunwharf Quays in February 2001. South of the canal is mostly residential (houses and apartments), while the north half comprises over ninety retail outlets, a twenty-six-lane bowling alley, a fourteen-screen Vue cinema, an art gallery, a casino, a nightclub, restaurants and coffee shops, and a hotel complex, plus 1,500 parking spaces. The Old Customs House pub/restaurant is the oldest surviving building on the site, originally an administration block dating from the late eighteenth century.

17. Old Engine and Pump House, Locksway Road, Milton, c. 1820

Hidden away among the ordinary suburban backstreets off Locksway Road, Milton, is the Engine House, actually then and now two houses back to back for the lock-keeper and pump operator employed by the old Portsmouth and Arundel Canal Navigation Co. This building, taken together with the short stretch of brick-and-stone sea lock and basin facing Langstone Harbour, next to the Thatched House (designated a conservation area and refurbished in 1977, renovated by members of the Portsmouth Society in 1990, and Grade II listed in 1999), are the only physical remains of the once ambitious, but now virtually forgotten, undertaking to link Portsmouth to London via the River Wey, then the Wey and Arun Canal to Arundel, then a canal south of Chichester and Thorney Island into Langstone Harbour. Construction started in 1818 following an Act of Parliament the previous year, and it was finished in 1823. John Rennie the Elder (1761–1821) was involved in surveying and planning. The complicated twin lock at Milton was by Josias Jessop – the resident engineer was James Hollingworth and it cost £170,000.

However, while the other sections of the canal continued in operation until 1847 and the Chichester arm until 1892 (when the company was finally wound up), the Portsea Island section was drained as early as 1827, following poor trade and saltwater contamination of the local residential wells. Even on the 1898 OS map all this area was still rural with Eastney Lake stretching further inland north of Bransbury Road, while the canal ditch was still clearly marked running parallel with Locksway Road (then called Asylum Road, after the Borough Lunatic Asylum, now St James Hospital), as far as the junction with Milton Road. As late as the first half of the twentieth century some traces of the canal bank could still be discerned in the front gardens of houses in what is now Goldsmith Avenue, dating from the 1890s (named after local landowner James Goldsmith), and which follows the former canal bed beyond the old White House pub, demolished in 2014. By 1847 the London & Brighton Railway had purchased the section

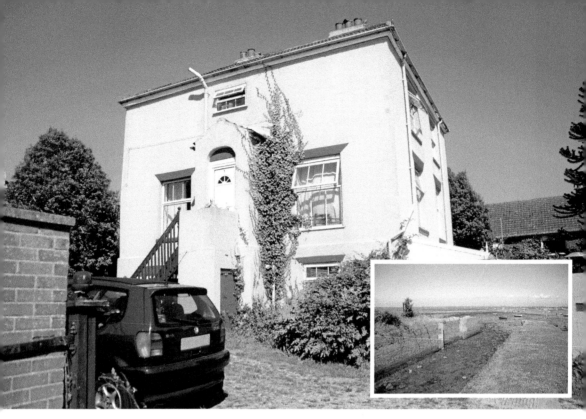

Old Engine and Pump House.

Inset: The canal mouth into Langstone Harbour (2016).

from what is now Fratton Station towards Portsmouth Town Station, along which we still find the road named as Canal Walk. The original Landport Canal Basin was on the site later occupied by the Allders department store (now, since 2013, Debenhams) on Arundel Street.

From the second half of the nineteenth century until the 1930s the Milton section was gradually filled in, in part with coke from the local gas works, and now only the former towpath still exists, nothing more than an undistinguished pedestrian footpath linking the various residential roads either side. Ironbridge Lane once lead to a footpath through fields and marsh, fringing Eastney Lake (Tideway and Kingsley Road being where it was since filled in and built over), while Artillery Terrace survive as a row of cottages, which, together with Alma Terrace, once stood in proud isolation on the south bank.

18. Former Guardhouse, Pembroke Road, c. 1834

Walking down what is now Pembroke Road from Penny Street towards Southsea Common one might be forgiven for barely noticing the small, undistinguished, single-storey brick cottage midway down on the right. Yet this was the guardhouse to the King William Gate leading out towards Southsea, the

last such egress being cut in 1834, and this modest little building, together with Landport, is now all that survives of the town's land fortifications. Previous to the nineteenth century there had been only a small footpath first to the Little Marsh, then the Great Morass, which once stretched from the shoreline back as far as today's Albert Road. By the early nineteenth century, however, Southsea was beginning to be developed as a town in its own right, initially with the Georgian terraces of Landport, Jubilee and Belle Vue, and the grid of so-called 'minerals' streets behind – Steel, Gold, Cooper and Silver, and Diamond Streets. The large pond between the gate and terraces was drained by the Board of Ordinance in 1836, thereby allowing further development. Colin White, in his essay on Lord Nelson's 'Last Walk' before departing for Trafalgar on 14 September 1805, described Green Row, as Pembroke Road from Penny Street was then called, as a 'dead-end', although Nelson's own account of a 'perilous' trip to Portsmouth in 1784 spoke of departing the town 'out at that the gate that leads to the Common'.

Originally the Long Curtain (1730) ran, as now, along the south side of Governor's Green, culminating in the King's Bastion of the same date. Extending out from the moat and drawbridge of the 1830s, King William Gate was the arrowhead-shaped King's Ravelin, with the Montague Ravelin to the north.

The former Guardhouse, Pembroke Road (2014).

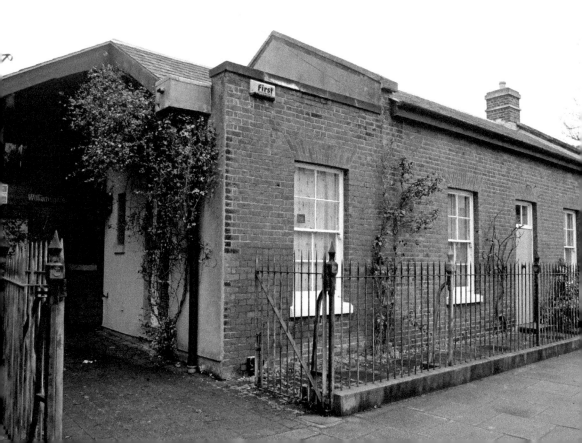

Beyond that Clarence and Cambridge Barracks were protected by the corner East Bastion. Following demolition in 1876, the town expanded north and east with the construction of St George's Road, Cambridge Road and Alexandra Road (now Museum Road). In 1880 more barrack accommodation, the Victoria Barracks (described by William G. Gates as 'magnificently flamboyant'), was then constructed where the complex of town walls had once stood, much of the work being done by convict labour. This was then passed over to the Royal Navy in 1945, but subsequent plans for the Royal Hampshire Regiment to be based there came to nothing, and they were demolished in 1967, to be replaced by the Crest Hotel and the Pembroke Park housing estate, although the Barracks Gateway can still be seen almost opposite the old guardhouse. In an 1870 photograph, the guardhouse still had an impressive three-columned portico facing onto the road.

19 and 20. No. 6 Boathouse, c. 1845, and Boathouse 4, Naval Dockyard, 1939

Despite being open to visitors and tourists, the Naval Docks is still a working yard, and the MoD's prime concern is function rather than the preservation of history or architecture. Now for security reasons the two are divided by a wire fence, but within the public sphere are the elegant red-brick Georgian storehouses, dating from 1764 and 1784, the end block being the National Museum of the Royal Navy. Opposite each other, separated by the Boat Pond, are two contrasting examples of naval architecture, each of its own time. No. 6 Boathouse, formerly a mast-house, was built between 1845 and 1848 for the repair and maintenance of small ship's boats. Its classical buff-brick exterior is rather austere and belies the innovative interior, it being one of the earliest buildings to use a sophisticated design of massive rounded-iron columns supporting horizontal girders and trusses intended to carry heavy loads on the floor above. Badly bomb-damaged during the Second World War, it later fell into disrepair, only to be rescued from 1998 onwards and has since been converted into Action Stations, comprising café, conference rooms, a 275-seat cinema/theatre, and various indoor, high-tech, interactive attractions.

In the same tradition but reflecting more modern developments in construction is the huge but strictly functional Boathouse 4, originally designed in 1938 as part of the rearmament program in the years immediately preceding the Second World War, constructed by the then Ministry of Public Buildings & Works in 1939. E. A. Scott is credited with designing the elevations, and the structure is by K. F. Buchanan, J. D. W. Ball and J. Angell. Incorporating its own dock and locks, it is typical of 1930s military industrial architecture, and, while its future was under threat even as late as 2000, it has since been converted into a boatbuilding skills training centre run by the International Boatbuilding College of Portsmouth and Highbury College, teaching the next generations of students to build and conserve wooden boats.

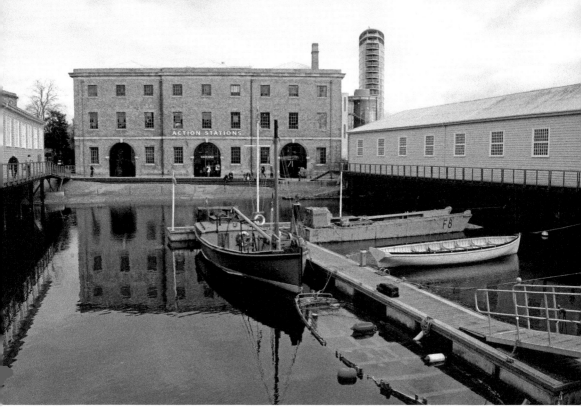

Above: No. 6 Boathouse, 2014.

Below: Boathouse 4, from Portsmouth Harbour (Gosport ferry), 2016.

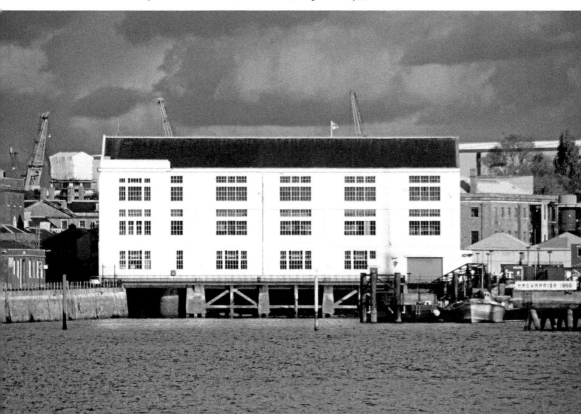

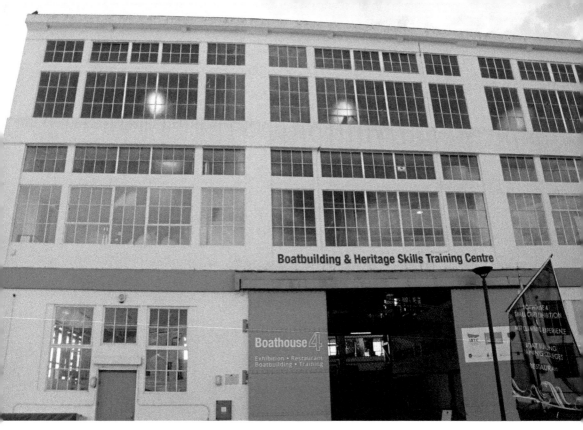

The Main Road entrance of Boathouse 4, 2016.

21. Portsmouth & Southsea Railway Station, 1847

In the eighteenth century the journey to and from London by road could take two days, with passengers often having to sleep overnight at Guildford. While nearby Southampton had a direct railway line as early as 1840, the military authorities continued to resist the intrusion of the steam railway across Port Creek onto Portsea Island until 1847, when eventually they relented (if still with reluctance – they insisted the railway company build a drawbridge), and a branch from the Brighton–Chichester line was allowed to cut through the Hilsea Ramparts and extend to what is now Portsmouth & Southsea Station. The following year the Eastleigh–Gosport line connected with the Brighton–Portsmouth line at Cosham, and both the London & South-Western Railway (LSWR) and the London, Brighton & South Coast companies jointly operated the tracks into Portsea. When finally a direct railway route via Havant and Godalming (subsequently taken over by the LSWR) was opened in 1859, the time taken to London had shrunk to a mere three hours.

The attractive red-brick façade of Portsmouth & Southsea Station (in what David W. Lloyd called a 'French Renaissance') dates from 1866, with the elevated island platform extending over Commercial Road (as it still was) dating from 1876. It was called Portsmouth Town from 1876 until 1921. Fortunately at least some of the internal fabric of the main station building can still be seen, although

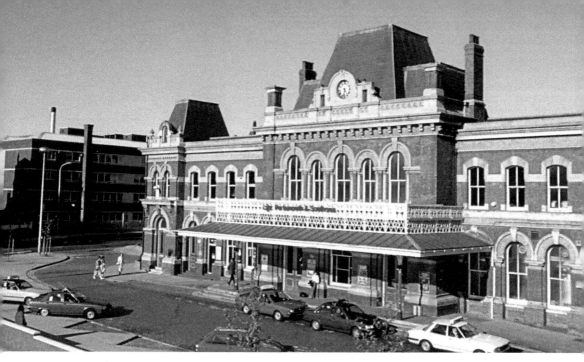

Portsmouth & Southsea Railway Station, late 1970s.

sometimes the twenty-first-century functions have changed – for instance the impressive former booking hall is now sadly devoid of purpose – but the glass canopy roof over the main concourse facing the lower-level platforms has survived.

Until the Second World War the area immediately south of the elevated platforms was occupied by a large goods station building, which fronted onto Commercial Road and Town Hall (later Guildhall) Square, and with the western arm of Greetham Street running south of that, emerging almost opposite the Guildhall steps, where the main body of the Civic Centre is now. From the 1940s until the 1970s this site remained derelict, until the development of the new Civic Centre complex. While the Victorian station has miraculously escaped obliteration (fated perhaps to be transformed into some bland and soulless 1960s glass box), almost everything below Greetham Street, right up to and including the former Hyde Park Road (now Winston Churchill Avenue) – buildings, history, even the very streets themselves – have completely vanished. Traces of the branch line that ran up across Edinburgh Road and along Unicorn Road to the naval dockyard could still be seen even in the late 1980s, but now that too has gone.

22. St Jude's Church, Southsea, 1851

Thomas Ellis Owen (1804–62) was an architect, businessman, local politician and property developer, and the man most responsible for the growth of Southsea, as well as neighbouring Gosport. An early detailed map of Portsea Island shows just Croxton Town (c. 1809–20, named after early developer Thomas Croxton, about whom very little is known), and north of the shingle shoreline just a few

roads criss-crossed the Great Morass, whose muddy creeks and pools reached as far north as modern-day Albert Road and Marmion Road, 'ill-drained and marshy, clad with scrub and gorse', to quote Sarah Quail. Other than a few houses dotted here and there, and Southsea Castle and the Lumps and Eastney shore gun platforms, settlement was confined to Fratton (clustered south of the old canal/railway), and the linear Kingston stretching along the road north, together with the small village of Milton to the east. Fast forward a few decades into the mid-nineteenth century and the modern 'New Southsea' has appeared, with much of the street layout we recognise today. During that transformation, between 1835 and around 1850, Owen designed and built 106 villas (no two the same, in both Gothic and Italianate style), fifty-four terraced houses, and a range of commercial, civic and religious buildings, the most notable being what became the parish church of St Jude's at the corner of Kent Road and Palmerston Road.

Thomas Owen was born in Dublin, where his father, Jacob Owen (1778–1870), was a civilian clerk of works, and later chief surveyor, then employed by the Royal Engineers department. Jacob, an architect in his own right, married twice; his first wife – Thomas's mother – Mary Underhill (1781–1858) having seventeen children in all! The family moved to Portsmouth around 1820, and in 1827–28 Owen Snr designed All Saints' Church, Landport, and Thomas probably contributed with his father on the original St George's Church, Waterlooville (1830, since replaced), and St John the Evangelist at Forton (1831), as well as St Paul's Church, Sarisbury Green (1836), and Holy Trinity, Fareham (1835–37). Thomas' least successful ecclesiastical venture was the 1843 rebuilding of St Mary's, Fratton, demolished and rebuilt less than half a century later, in 1887. By contrast, St Jude's was in the early Victorian style, with flint and stone dressings, described as 'handsome' by William White, although David W. Lloyd is a bit dismissive saying, 'It is hardly a "correct" church in the Gothic Revival sense' – maybe, in retrospect, no bad thing. Some sources state it cost in total £5,000, £700 to purchase the land, then part of St James Farm, owned by T. Burrill, and the church building itself £3,000, £2,300 of which was Owen's own money, the remainder from benefactors and a grant from the Admiralty, as the 45-metre- (approximately 147-foot-) high steeple would be a useful focal marker for shipping. It was consecrated on 3 June 1851 by Charles Sumner, the Lord Bishop of Winchester, with the bishop's son, Revd W. Sumner, as chaplain and the former curate of Steep, near Petersfield, Revd T. R. Brownrigg, as the first vicar until 1869. At the comparative young age of thirty-one, he was also Thomas Owen's son-in-law, having married the architect's daughter, Louisa Anne. Under the fourth incumbent, Rt Revd Ernest Graham Ingham (b. 1851), author, doctor of divinity, and former Bishop of Sierra Leone, vicar from 1912 until his death in 1926, St Jude's became more evangelical. The vestry was enlarged in 1897 by J. H. Ball (a local architect and friend of Arthur Conan Doyle), but much of the elaborate Victorian interior, dating to 1876 and by A. Jowers, was lost in urgent redecorations undertaken in 1973 to correct structural problems with the west wall. In 2010 an ambitious £2.4-million project was began on a new glasswork entrance, together with new offices, kitchen and toilets, to create the concept of a 'church without walls'. The designers were Lee Evans Partnership.

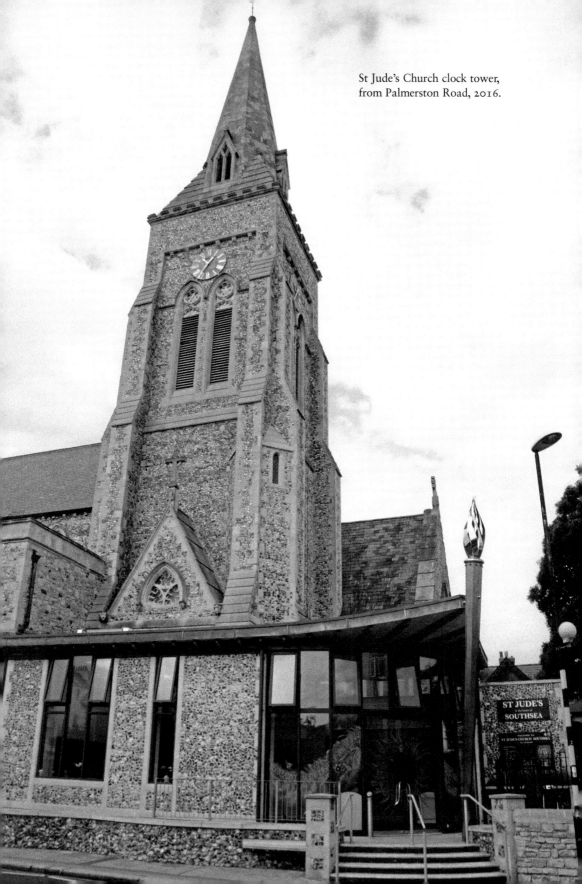

St Jude's Church clock tower, from Palmerston Road, 2016.

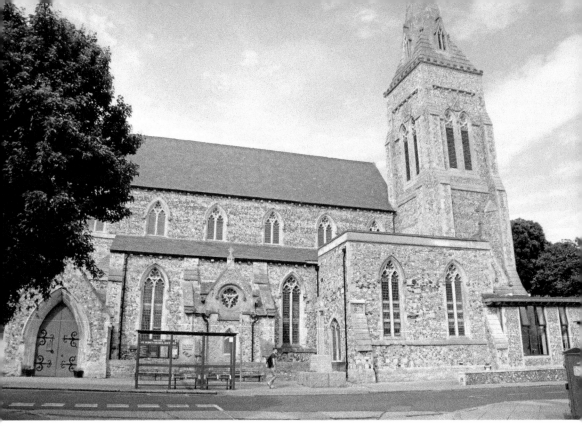

The church from Tonbridge Street/Kent Road (2016).

23. Cambridge Barracks, now Portsmouth Grammar School, High Street, 1856

Until well into the first half of the nineteenth century soldiers stationed in Portsmouth were often billeted at hotels, inns, or private houses – none of which were conducive to good discipline or behaviour – or they were forced to share overcrowded and often unsanitary accommodation in the older barracks buildings, or in Gosport. In 1760 the Fourhouse Barracks (named after a nearby brewery) was opened in St Nicholas Street, but was subsequently renamed Clarence Barracks after the Duke of Clarence, following his visit in 1827, as Lord High Admiral. Eventually, in 1856, in the aftermath of the Crimean War (1853–56), the government purchased land at the top right-hand side of the High Street, demolishing a number of ancient historic properties including the then Portsmouth Theatre and constructed the Cambridge Barracks, originally with the soldiers' quarters – which included the then novel idea of married quarters – stables, wash-houses, cookhouse and canteen aligned with the top end of Penny Street, and the more imposing façade of the Officer's Quarters block (with servants' quarters, kitchens, wine and beer cellars) fronting onto the High Street itself. It was named after Prince Adolphus Frederick, seventh son of George III and the 1st Duke of Cambridge, who died in 1850, although his son George, the 2nd Duke (1819–1904), was more closely associated with Portsmouth, being an

army officer and commander-in-chief for thirty-nine years. He opened the new Cambridge Road in 1864, connecting the High Street with Commercial Road. Designed by the Royal Engineers with what has been described as a 'handsome restrained classical façade' using yellow Sussex brick, the builder was a local firm, Lee & Laver. Thirty years later, in 1887, a gas explosion blew out a chunk of the three-storey wall, hurling debris across the wedge-shaped parade ground, killing five members of the Worcestershire Regiment and injuring fourteen.

After the First World War the barracks fell into disuse, and in 1926 the then headmaster of Portsmouth Grammar School, Canon Walter J. Barton, proposed the purchase of the derelict officer's block and adjacent parade ground. Following an appeal, which raised £18,000 (together with a generous donation from shipping magnate Sir Heath Harrison), this became the main upper school in 1927. The grammar school already had an illustrious history, being founded in 1732 by Dr William Smith, physician to the garrison and one-time Portsmouth mayor. He left money to Christ Church College, Oxford, to help 'meet the educational needs of the population'; however, the first headmaster, Revd Benjamin Forester, did not take office until 1750. The school was in effect 'refounded' in 1878, when it moved to its two-storey, red-brick, purpose-built Victorian building, now the Lower School opposite on the corner of Cambridge Road and St George's Road, which was designed by local architect A. E. Cogswell and opened in 1879. But Barton's problem in 1926 was that this old school

Portsmouth Grammer School along the High Street, looking north (2015–16).

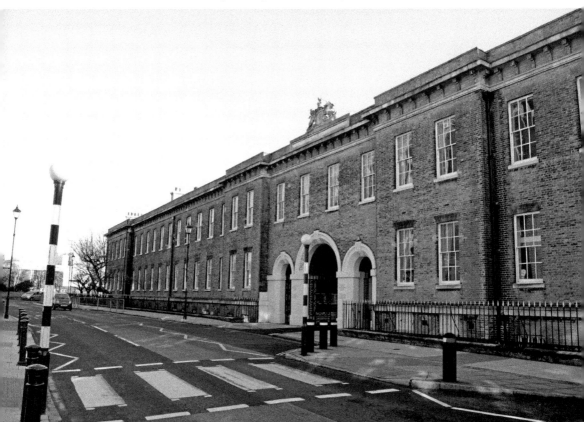

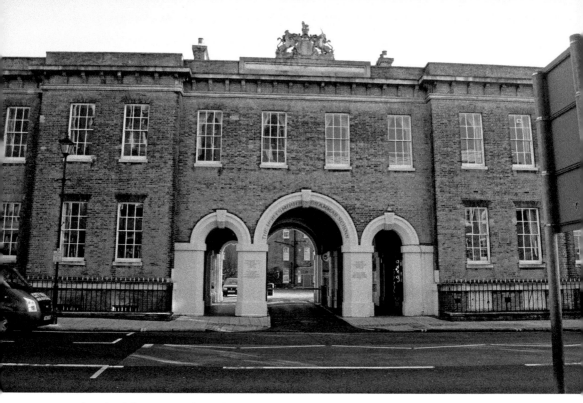

The school from across the High Street (2015–16).

building had been designed for 250 boys and it was now 'dirty and overcrowded with 525 boys'.

According to archivist John Sadden, the school was hit by a number of incendiaries during the Second World War, causing some damage, especially to the older 1879 building (now the Upper Junior School), while another bomb – quite recently discovered – had apparently hit the playground, narrowly missing the 1850s buildings. The first female pupils started in the sixth form in 1976, but it was some years before the school became fully coeducational.

24. New Theatre Royal, Commercial Road, 1856

The original Theatre Royal was located in the High Street, built in 1761 and demolished in 1854 when the site was acquired by the War Office for Cambridge Barracks. Sometime in the early nineteenth century a racquets court was built next to the White Swan Tavern in Commercial Road, which in 1854 was replaced by Landport Hall, designated 'a meeting place for townsfolk'. In 1856, circus proprietor and theatrical entrepreneur Henry Rutley (then also the owner of the White Swan), converted this into a theatre, and, following his death, it was taken over by John Waters Boughton and rebuilt in 1884 as the New Theatre Royal to the design of renown theatre architect C. J. (Charles John) Phipps (1835–97). Later still, in 1900, Boughton commissioned the architect Frank Marcham (who also

designed King's Theatre in Albert Road) to extend the auditorium and construct the distinctive cast-iron balcony to the street façade. From 1932 to 1948 it was a cinema, and during that time King's (opened in 1907, also owned by Boughton, originally 2,172 seats, now reduced to 1,600) became Portsmouth's principle theatre, staging plays, ballets, musicals and opera. Boughton died in 1914 but his company, Portsmouth Theatres, continued to run Kings until 1964 when it was bought by local industrialist Commander Reggie and Mrs Joan Cooper. Featuring live entertainment again, the Royal had a new lease of life as a variety theatre until October 1955, when it closed, only to reopen in 1957 as a repertory theatre. From 1960 to 1966 it was a wrestling arena and bingo hall. There then followed a long period of mixed fortunes and uncertainty, with bitter disputes over which theatre – King's or the Royal – should survive, and which to sell off and demolish. At one time Hove developer Norman Byre proposed either an office block or a ten-storey, 214-bed hotel on the Commercial Road site (it only became Guildhall Walk in 1976), or alternatively a supermarket and flats to replace King's. In the modernist spirit of the time, the Theatre Royal was described dismissively as a 'decaying monument to Victorian theatrical architecture' and there was 'no need for theatres, now or in the future'. The city council too often showed little enthusiasm to protect or promote the arts. By the 1970s, from having six theatres at the beginning of the century, Portsmouth was in danger of having none. In 1968 the Royal was occupied by squatters, but worse was to come when, in 1972, it was badly damaged by a fire,

New Theatre Royal (2016).

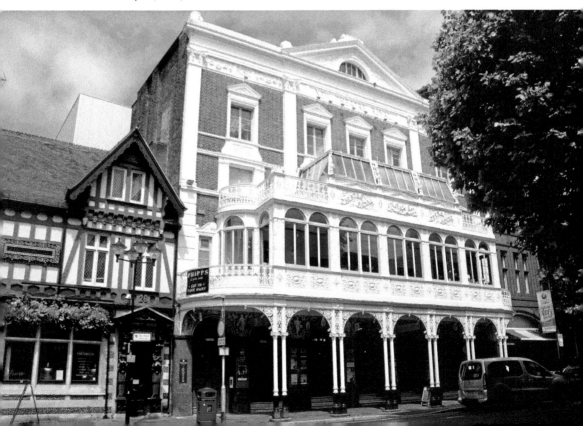

believed at the time to have been set off by children playing with fireworks, and it was badly vandalised again in 1973. In 1975 the Theatre Royal Society (founded in 1970) set up a trust company, and in that year the application for demolition was refused (by one vote), although it still remained derelict. Somehow, against all odds, the Royal survived into the 1980s, and finally in 1983/4 a £2.5-million restoration began and in 1986 it saw its first performance in twenty years, while – another plus – the Conservatory Café opened in 1987, bringing greater public access and revenue. Meanwhile, in 1990, King's had been bought by Hampshire County Council, sold to Portsmouth City Council later in 2001, who leased it to the King's Theatre Trust Ltd. It too saw extensive restoration in 2008/9. The Royal also saw further restoration in 2004, and in 2015 the auditorium seating was increased from 500 to 700. It is now in partnership with the University of Portsmouth.

25. Former Royal Marine Barracks, Eastney, 1862

Even now what was once the Royal Marine Barracks dominates Eastney. Most of Portsmouth's other barracks blocks, with the exception of the grammar school and City Museum, have gone, but here we have – almost in its entirety –

Former Royal Marine Barracks entrance, Eastney, 2015.

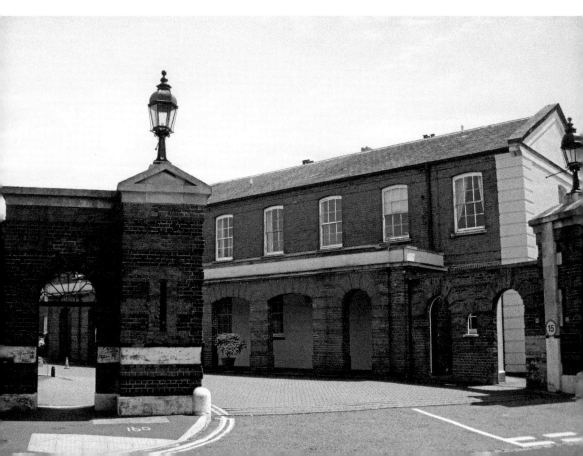

The barracks' clock tower, from Cromwell Road, 2015.

an example of Victorian military architecture. Originally there was a Tudor gun battery here, between Lumps Fort and Fort Cumberland, but all traces of this was finally obliterated in 1921, with the creation of a public promenade. The barracks were designed by William Scamp (1801–72), an outstanding civil engineer who rose to be Deputy Director of Engineering and Architectural Works for the Admiralty, and whose work included military buildings at Davenport, Woolwich, Chatham, Gibraltar, Bermuda, and (from 1841 to 1844) Malta, where, among other notable contributions to that island, he made modifications and undertook the construction of the St Paul Anglican Cathedral in Valletta.

There were seven linked blocks (six were later listed) and it comprised 37 acres, 14 acres of open space and a further 21 acres of open playing fields, stretching from the main entrance and keep-like clock/water tower in Cromwell Road, south of Henderson Road (named after Lady Anne Isabella Henderson-Durham, second wife of Admiral Sir Philip C. Henderson Durham, part of whose the land of Eastney Farm was sold to the War Office following her death in 1844), to what was the sewage pumping station (built in 1868) at the junction of Henderson and Bransbury Roads. It had the largest barracks frontage in the country after the Royal Artillery Barracks at Woolwich, and was the headquarters of the Royal Marines Artillery, who moved here from Fort Cumberland in 1867, and remained the corps HQ until 1995. It was an almost completely self-enclosed world, with its own theatre/cinema, drill hall, gymnasium, library, school, hospital, allotment gardens, swimming pool and football and cricket grounds, while St Andrew's Church dates from 1905. The Royal Marines Museum was first established here in 1958, and since 1975 occupies what was the former Officers' Mess (1865), with its elegant Jacobean-style loggia and staircase. In 2013, when the suggestion was first made to transfer the museum to the Naval Dockyards (now planned for 2019), annual visitor numbers were quoted as 29,000. There is still considerable controversy over moving Philip Jackson's the *Yomper* statue, which has stood guard at the museum car park entrance since it was unveiled in 1992 by Margaret Thatcher to commemorate the 10th anniversary of the Falklands War. The marines moved out in 1991, and – with the exception of the Officers' Mess block – the rest of the barracks was sold for residential use.

26. Spit Bank Fort, the Solent, 1861

1852 onward saw the final phase of Portsmouth's military defences initiated by the 3rd Viscount Palmerston, Henry John Temple (1784–1865), the former Tory politician, later defecting to the Whigs and who eventually saw their transition into the Liberal Party in the 1850s. He was foreign secretary from 1830 to 1841, again from 1846 to 1851, and prime minister from 1855 to 1858 and 1859 to 1865. Throughout this period he became deeply concerned by the potential threat, and possible invasion, posed by French Emperor Napoleon III (1808–73). In reality there does not seem to have been any such

plan, and, indeed, the military prowess of the emperor was in no way equal to that of his illustrious uncle and namesake. In 1870 he suffered defeat and personal captivity by the Prussians and ironically was later forced to flee to England the following year, where he subsequently died in exile.

However, this period of perceived threat saw the construction of Fort Gomer, near Stokes Bay (since demolished) and Fort Elson, north-west of Gosport, start in 1852, then (following recommendations in 1857) Forts Brockhurst, Rowner and Grange built between 1858 and 1862. In 1859–60 the Royal Commission on the Defences of the United Kingdom made further recommendations for a series of land forts to be built along Portsdown Hill ridge, and – following a lively debate in parliament – five such forts were constructed: Widley (completed in 1865, now owned by Portsmouth City Council), Southwick and Purbrook (both completed in 1870), Nelson (now an artillery museum, Grade I listed) and Wallington (since part demolished, both operational in 1871). The smaller Farlington Redoubt was demolished in the 1970s. In addition Fort Fareham was built from 1861 to 1868, completing the line defending the Gosport peninsula.

Spit Bank Fort. Although not especially good quality, these 1991 photos were taken when it was still possible to visit. It was then still in 'fort mode' rather than a luxury hotel with a helicopter pad!

However, perhaps the most spectacular and ambitious of what became known as 'Palmerston's Follies' were the four sea forts constructed as miniature artificial islands between Portsmouth and the Isle of Wight – the two largest being Horse Sand Fort (1865–80) and No Man's Land Fort (1867–80), and the two smaller forts St Helen's (1867–80) and Spit Bank (1867–78), the latter being the nearest to the mainland. Five forts were originally proposed, but at least three sites proved to be physically unsuitable, and St Helen's (the smallest) was included later. All are now in private ownership – since 2012 Spit Bank, Horse Sand and No Man's Land by Clarenco LLP, but in the early 1990s it was still possible for the public to visit Spit Bank Fort, which is when these photographs were taken by the author. Spit Bank – a scheduled monument since 1967, and finally decommissioned by the Ministry of Defence in 1982 – was reputedly sold for over £1 million in 2009, and is now a luxury nine-bedroom spa hotel.

27. South Parade Pier, Southsea, 1879, Rebuilt in 1908

In the second-half of the nineteenth century Southsea grew rapidly. To give just one example (from Sarah Quail's *Southsea Past*), between 1847 and 1885 the number of registered lodging houses went from thirty-eight to 368. New and grand hotels sprung up: the original Queen's Hotel in 1861, converted from what had been Southsea House; the Pier Hotel (following a stay by Queen Victoria, the Royal Pier Hotel) opened in 1865 with sixty bedrooms. It was converted into student accommodation in the 1960s and demolished and rebuilt as a students' hall of residence in 1995. The Beach Mansions Hotel (now Best Western Royal Beach Hotel) was built in 1866 with 140 bedrooms, and the upper floors were rebuilt after a fire in 1911. The Sandringham Hotel was built in 1871 and enlarged in 1880. The Grosvenor Hotel and Esplanade Hotel followed. Clarence Esplanade Pier opened in 1861, was enlarged in 1869–71 and again in 1874–75, serving the Isle of Wight ferry, but soon as a place of entertainment also. It was further extended in 1905 and again in 1932, only to be destroyed by bombs in 1941. Work to rebuild it started in 1953, eventually reopening in its present form in 1961, partly to a design by A. E. Cogswell & Son architect R. Lewis Reynish, while the deck and 60-foot steel-frame tower was by Mouchel & Partners of London.

South Parade Pier, between Southsea Castle and Lumps Fort (now the Rose Garden), was opened in 1879 by the wife of the then Lieutenant Governor, Prince Edward of Saxe-Weimar-Eisenach. William G. Gates reported that it took six months to build, the engineer was Mr George Rake, and it cost just over £9,000, while pile driving had been made difficult for around a tenth of the 600-foot length by the remains of a submerged forest or belt of trees. It was badly damaged by fire in 1904 and remained derelict for two years during which time it was sold to Portsmouth Corporation for £10,782, before

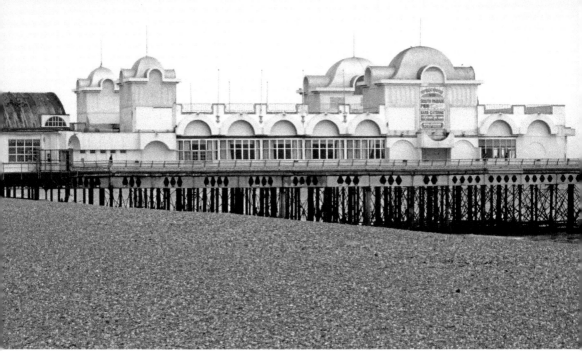

A general view of the pier looking east (2014–15).

being rebuilt in the more recognisable, typically Edwardian appearance we see today, to the design of local architect G. E. Smith (1868–1944), and opened in 1908 at a cost of £85,000. It was partially dismantled during the Second World War, and the magnificent 1,200-seat theatre was demolished in 1967. It too suffered several fires, the most notorious being in June 1974 during the shooting of Ken Russell's movie of The Who's 1969 rock opera *Tommy*. The Gaiety Theatre was being used for the interior of the ballroom sequence at 'Bernie's Holiday Camp' (Russell used the old Hilsea Lido for exterior shots) when a fire broke out, the smoke actually being seen on camera as Oliver Reed and Ann-Margaret dance together. The crew continued filming and the blaze was included in the final movie.

Originally sold to a business consortium in 2010 who pledged to 'restore it to its former glory', by 2012 little had happened, and in April of that year the promenade deck was closed for health and safety reasons, leaving only limited access for fishing. By November, however, the complete pier was closed and fenced off, although the retail units and parts of the arcade not over the beach or sea continued to still function for a while after. In December 2012 an attempt to sell it at auction failed, but in 2014 another consortium, South Parade Pier Ltd, made new, and perhaps overambitious proposals, at least one of which – a 'London Eye'-style big wheel – has since appeared at nearby rival Clarence Pier instead. Subsequently promised openings were delayed from 2015 into 2016 'due to bad weather and other factors'. Although the shops facing South Parade resumed trading in April 2015, the structural integrity of the deck suffered another setback following storm damage in February 2014. At the time of writing, in the second half of 2016, the pier is still out of bounds.

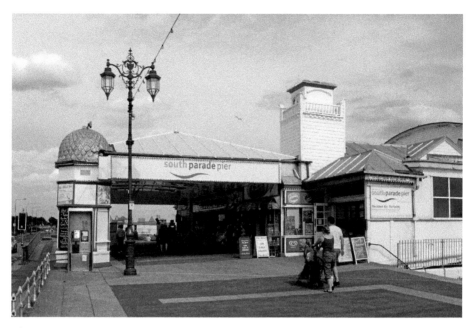

The entrance to South Parade Pier, Southsea (2014–15).

28. Catholic Cathedral of St John the Evangelist, 1882

It was only after the Second Catholic Relief Act of 1791 was passed by Parliament that Catholics were allowed to have chapels in major towns or cities, and in that year John Cahill converted a private house in Union Street as the first place of worship, to be followed in 1796 by a purpose-built 300-seat chapel in Prince George Street under his successor Joseph Knapp. This was enlarged in 1851. Following the clearance of the town's fortifications, in 1877 a competition was held for the design of a new church in Edinburgh Road, won by John A. Crawley, who had previously built St Joseph's, Havant, and the Sacred Heart, Fareham. He died in 1881, a year after construction started on the large cruciform church, to which he also originally intended to include a 200-foot-high spire located at the south-west corner. His successor was Joseph Stanislaus Hansom (1845–1931), son of Joseph Aloysius Hansom (1803–82, prolific architect and, in 1834, inventor of the prototype 'hansom safety cab'). Hansom Jr modified the design, while local geology prevented the spire being built. Progress was slow, however, with the nave finished and consecrated in October 1882, the crossing in 1886, the chancel in 1893, the narthex (entrance lobby) and west porch, with its two turrets, in 1906, this last to the design of architect-priest Canon Alexander Scoles (1844–1920). The style has been described as French Gothic Revival, executed in Fareham red brick and Portland stone.

The Southwark Catholic diocese having become too large for one bishop, in 1882 Leo XIII issued a papal brief creating a new diocese from its western flank, which comprised the County of Hampshire, the Isle of Wight, Channel Islands,

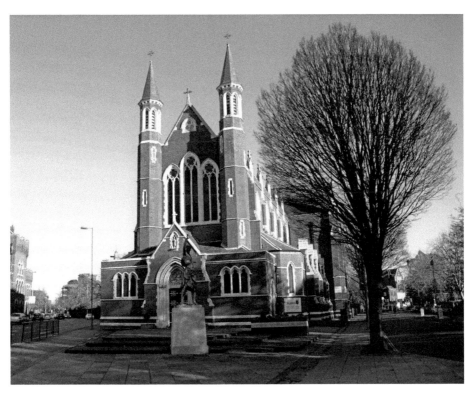

Catholic Cathedral of St John the Evangelist, from Queen Street/Anglesey Road (2016).

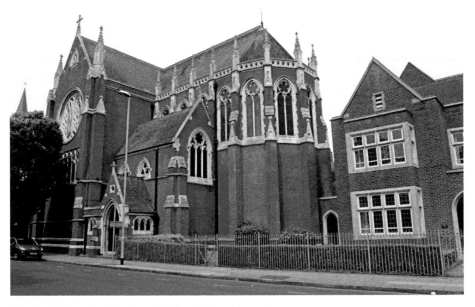

The Catholic cathedral, from Edinburgh Road (2011).

and Berkshire. The reason generally given for not having its cathedral located in Winchester is the 1851 Ecclesiastical Titles Act, which forbid Catholics using titles of existing Anglican sees, but even before plans for the new diocese were being formulated, the Act was repealed in 1871. The initial choice was the church of St Joseph in Bugle Street, Southampton, but inevitably the much larger new church of St John the Evangelist became the pro-cathedral instead, with Dr John Vertue (1826–1900) as the first bishop. It suffered bomb damage in 1941, which saw the bishop's house (also in Edinburgh Road) destroyed. It was restored in 1950, while extensive interior alterations were made in 1970–71, 1982 and 2001. John Offord was probably not alone in bemoaning the wanton post-Vatican II destruction of Hansom's 'magnificent Italian-Gothic baldachino', which once stood above the high altar, but then he thought the interior had 'no intrinsic beauty', and regretted that Crawley's 'grand design' had never been fully implemented.

The prominent 8-foot-high statue of St John, unveiled in 2012, is by sculptor Philip Jackson (b. 1944).

29. Town Hall, later Guildhall, Guildhall Square, 1890

The previous town hall had been located at Nos 42–43 High Street, a modest classical building constructed in 1837–38 and designed by Benjamin Bramble. Even at the time it was too small and in the wrong location, but it was not until 1879 that the Municipal Corporation decided on a new building, more in keeping with Portsmouth's growing status, to be built on the west side of Commercial Road and to the south of the town's railway station, where there had once been a brewery, later the residence of the officer commanding the Southern District Artillery. The old town hall subsequently became the town museum, eventually to be bombed in 1941 and the ruins demolished ten years later. The new building was constructed in 1886–90, essentially to a design by William Hill (1827–1889) from Leeds, who had previously designed the town hall at Bolton in 1866–73, although working in partnership with local architect Charles Bevis. The contractors were Messrs Armitage & Hodgson of Leeds, who built both the Bolton Town Hall and Wakefield County Hall. At the time it was the most monumental and unprecedented example of civic architecture in Portsmouth, and the interior was equally stupendous, with a 129-foot-long, 70-foot-wide and 60-foot-high great hall, seating for 2,000, and the largest organ in the south of England, by Gray & Davidson. In addition to the council offices and chambers, there was also accommodation for the police station and courts. It cost £137,098 and was opened on 9 August 1890 by the Prince and Princess of Wales. Finally, in 1926, Portsmouth was elevated to the status of a city, and it became the Guildhall, with Councillor Frank Privett as the first Lord Mayor.

Sadly this magnificent building, and most of its irreplaceable contents, was destroyed by incendiary bombs in January 1941, which left only the shells of the four walls and tower (where the public records were stored.) Bowing to public

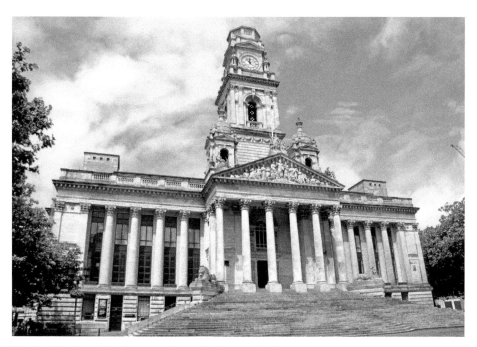

The Guildhall, Guildhall Sqaure, formerly the town hall, 2016.

pressure, it was eventually lovingly rebuilt in 1955–59 at the cost of £1.5 million, the architect being E. Berry Webber (1896–1963), whose work also included Southampton's 1928–39 Civic Centre. However, while preserving much of the appearance of the previous exterior, the beautiful spire-like dome on the clock tower and the delightful minarets on each side have been lost from the original. It was reopened by Her Majesty the Queen on the 10 June 1959.

30. Brankesmere House, Queen's Crescent, Southsea, 1896

Brankesmere House was built in 1895–96, apparently replacing two Thomas Ellis Owen villas, the style being a mixture of 'Jacobean, Tyrolean and French' (David W. Lloyd), or alternatively 'Tyrolean Tudor'. It was built for John Brickwood, owner of Brickwoods Brewery and pub chain, who was also the first chairman of Portsmouth Football Club from 1898. His friend Dr Arthur Conan Doyle (whose surgery was at the junction of King's Road and Elm Grove) had played for the amateur club that preceded it. The architect was another friend and fellow Freemason, A. E. Cogswell, also chief architect for many of the mock-Tudor style of Brickwood's public houses. Sir John (as he was after 1904) had first married Eliza Miller in 1881, but she died in 1887. Both she and their only daughter were drowned in separate incidents. John then married Jessie Cooper in 1893 and they had two sons, the younger being Rupert (b. 1900, later 2nd Baronet Brickwood and company director), but the

Brankesmere/Byculla House, Queen's Crescent (2016).

eldest son died in action in 1915 and Jessie (Lady Brickwood, as she then was) died of ill health in 1917.

During the First World War the house was used by the Red Cross as a hospital, and the name changed to Byculla House in 1923, when it became a girls' school – 'School for Daughters of Officers & Profession Men', as if the 'daughters' didn't have mothers! It was vacated in 1940 and soon after became the Portsmouth Police Force headquarters until they were merged into the Hampshire Constabulary, and the divisional headquarters moved to Kingston Crescent after it opened in 1962. Finally, in the mid-1970s it was taken over by Hampshire County Council and Social Services until 2004. Restored by PLC Architects, it has been converted into offices and two dwellings. It was Grade II listed in 1972 and has now reverted to its original name.

31. Former Pearl Building, Commercial Road, now Charter House, Lord Montgomery Way, 1899

In 1891 the Prudential Mutual Assurance Investment and Loan Association (to give it its original full name, founded in 1848) opened a branch office in Commercial Road, since renamed Guildhall Walk. The building (Grade II listed in 1972) was designed by the architect Alfred Waterhouse (1830–1905) in what became his company style for the Prudential of red brick and red-brown terracotta, and quite similar to his later Southampton branch, above Bar Street, of ten years later. In 1899 their business rival, originally called the Pearl Loan Co. (founded in 1857, they changed their name to The Pearl Assurance Co. in 1914) had their – much bigger and grander – Portsmouth branch office erected at what was then the very southern end of Commercial Road, at the junction with Cambridge Road, now Lord Montgomery Way.

This was known as Pearl Buildings, now called Charter House. The *Building News* for 24 February 1899 reported,

> Besides the company's own offices, it will comprise four shops, suites of offices on the upper floors, and a private hotel. It is being built with red brick and Portland stone to the main fronts, and the walls of the internal court are being faced with Wortley white-glazed bricks relieved with coloured bands. The dome and cupola will be covered with copper. The carving is being executed by Mr Syd Horsman, of London, and the fireproof staircases, etc., by Messrs. J. L. Wilkinson and Co., of Westminster. The building is being erected by Mr J. H. Corke, of Portsmouth, from the designs of Mr C. W. Bovis [*sic*], F.R.I.B.A., of that town. Mr A. J. Lewis is the clerk of works.

In 1890 local Southsea architect Charles William Bevis (1854–1927) – note the *correct* spelling – had previously worked with William Hill on what later became the Guildhall, and also designed the United Reform church at the junction of Stafford Road and Victoria Road South in 1911. The style of the Pearl Buildings

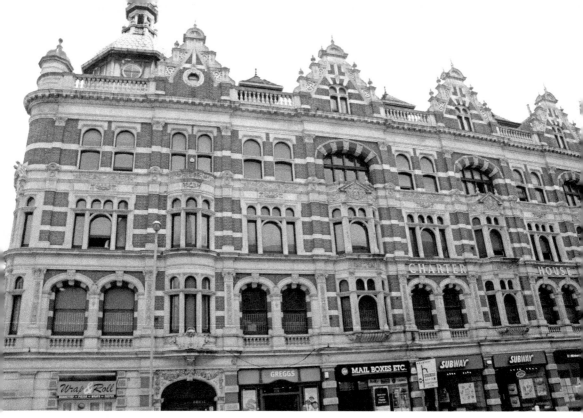

Two views of Pearl Building/Charter House (2015–16).

is Flemish Renaissance, and, with its striking skyline, it was once one of the largest and tallest buildings in Portsmouth, and it is still impressive today. In addition to Pearl Assurance, the *Kelly's Street Directory* for 1906–07 lists the Washington Private Hotel, in 1910–11 renamed the Washington Temperance & Commercial Hotel, and Curtiss & Sons, shipping agents, railway carriers, furniture removers and warehousemen (by Appointment to His Royal Highness the Prince of Wales). Post-war *Kelly's* also shows that the name changed from Pearl Buildings to Charter House sometime between 1960 and 1962, when Pearl Assurance too was no longer listed as occupants. However, someone who started working in Charter House in 1966 said that *even then* they were still getting correspondence addressed to 'Pearl Buildings'. The address changed from Commercial Road to Lord Montgomery Way around 1976. The ground floor of Charter House is still retail, but the upper floors are being converted to residential use. It was Grade II listed in 1972.

32. The Seagull, No. 13 Broad Street, Point, 1900

According to Ron Brown, what is now The Seagull was formerly known as Peabody's Vat, a Jewell Brewery house, and the first mention of a 'drinking place' on this site was as early as 1802. Dormer Jewell (1805–72) & Son had their brewery in Catherine's Row, Portsea, off Queen Street, but following the death of Dormer's son Edward William Jewell, the business, which by then included seventy-two pubs, was sold to Brickwood's Brewery in either 1898 or 1899, for £265,000 – then a quite considerable sum. By the mid-nineteenth century Brickwood's, who had their origins in London, were a major player in the Portsmouth area, expanding first under Henry Brickwood, who in 1848 was the licensee of the White Hart Brewery in Queen Street, and then the sons of his sister-in-law, Fanny Brickwood, Arthur (d. 1894) and John Brickwood (b.1852, knighted in 1904, d. 1932). Eventually the empire was brought together as Brickwood's & Co. Ltd registered in 1891. They continued to grow and expand until they eventually sold to Whitbread in 1971, by which time there were 670 tied houses across Hampshire. The Queen Street brewery, by then known as Portsmouth Brewery, was closed in 1983.

What was to become The Seagull was rebuilt around 1900–04, and, while the corner 'wizard's hat' turret and half-timbered upper storeys were very characteristic of local Portsmouth pub architect Arthur Edward Cogswell (1858–1934), local historian Stephen Pomeray states it was designed by another locally based architect, George Charles Vernon-Inkpen (1857–1926), a Londoner originally from Bethnal Green but living and working in Southsea from the early 1890s, later elected as a borough councillor in 1898–1903 for Havelock Ward. He was described as having 'designed several city schools and several public houses'. He also registered a patent for a 'concrete screw-pile for foundations' in 1913. The Seagull was listed as a 'beer retailer' in the

The Seagull, 2015.

Inset: Still a restaurant in the 1980s.

1909–10 *Kelly's Directory*, but as a 'public house' throughout the 1950s up until 1970. It was then listed as being a restaurant from 1972 until the final edition in 1976. It was Grade II listed in 1999, and became Fry & Kent Estate Agents in 2001.

33. The Clock Tower, No. 44 Castle Road, Southsea, c. 1903

Contemporary with 'The Seagull', and in the same distinctive mock-Tudor local style, is the Clock Tower situated at the junction of Great Southsea Street and Castle Street, also known locally for many years as being the commercial address of A. Fleming (Southsea) Ltd, the antique dealers who only ceased trading in 2015 after 108 years of business. This was perhaps the oldest part of what is now Southsea, with Southsea Lodge, No. 17a Castle Road, dating to 1790. However, development really began in the early nineteenth century, with the area between Castle Road and Victoria Road South built between 1835 and 1860. Although originally mostly houses for artisans, it eventually also had a middle class as well as industrial mix, with shops, pubs, Long's Brewery in Hambrook Street, repair garages, builders' yards and a haulage deport.

Apparently this site was purchased by George Gale of Gales Brewery in 1902, and the building was constructed around 1903 by architect W. J. [Joseph]

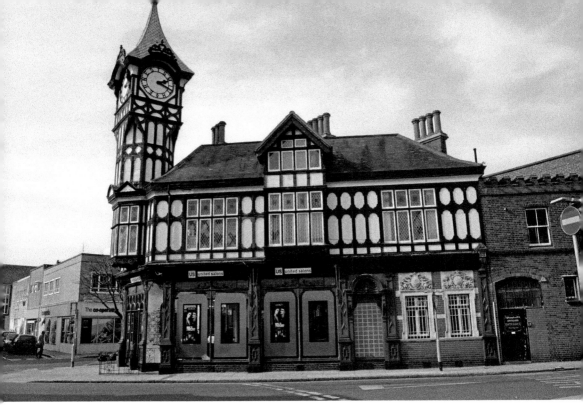

The Clock Tower, as seen from St Edwards Road in 2014.

Walmsley, with the builder being James Cockerill of Victoria Road, Southsea. One interesting feature is that in lieu of clock numerals are the letters ERNEST SMITH, the name of the original antique dealer who first leased the property until his death in 1922. The Ford Motor Co. then took over the lease, and it remained a car showroom until around 1941 when taken over by A. Fleming after they were bombed out of their previous premises just 50 yards away in Castle Street. The founder, Alfred Fleming, had died in 1932, and the business was subsequently run by his sons, Jack and Alfred, then his grandson, also Alfred, until he retired aged seventy-four. In their heyday they were a 'mini-empire' with branches in Pall Mall, London, and a worldwide export business. Queen Mary, the wife of George V, and the Emperor Haile Selessie of Ethiopia were among their customers.

The origin of the two wooden medieval soldier statues flanking either side of the main doorway (inevitably named as Gog and Magog) is something of a mystery, and they had been removed after being vandalised when I took my photograph in around 2014, but since restored and returned in 2016. The building is now occupied by a number of small businesses.

34. Tower House, Tower Street, Point, 1906

The late Victorian and Edwardian maritime painter William Lionel Wyllie (1851– 1931, better known by his initials 'W. L. Wyllie') was already a well-known, highly

respected artist, with perhaps his most innovative work already accomplished, when chance brought him to live in Portsmouth. In 1879 he married Marion Amy Carew, who he had first met nine years before as a young ten-year-old girl, and in 1885 they rented Hoo Lodge, overlooking the Medway at Rochester, where they lived happily for the next twenty years until the owner decided not to renew the lease. By then they had five sons and two daughters (two more boys having died as babies). However, Marion, while visiting Portsmouth, happened to accompany her cousin who was going fishing for bass on the terrace of an old boat store next to Capstan Square. The building – 'a three-floored premises forming the Yacht Chambers, Stores and Wharf' – was to be auctioned by the executors of the late E. F. Quilter, Esq., and straightway that day Marion wrote to her husband 'I have found a house for you', and which he purchased in May 1906. Also included in the auction were Nos 3–5 Tower Street, the former once being the Black Horse Tavern (now Black Horse Cottage) and the existing building was probably eighteenth century, despite a wall plaque date given as '*c.* 1657'. The pub had continued trading until around 1896, the last licensee being Samuel Goddard.

Wyllie lived here until his death (in *Kelly's* he is listed as 'Major W. L. Wyllie, R. A., artist') and his widow until she died in 1937. Over the subsequent two

Tower House, from Capstan Square, 2015.

Inset: Capstan House gateway, as seen in 2011 before being incorporated into the building extension.

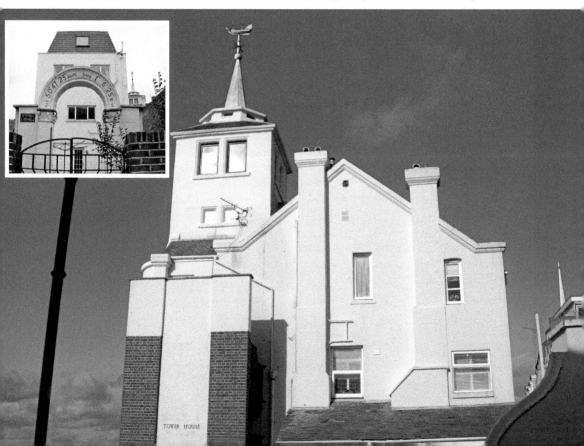

decades from 1906, the original building (which sources date to around 1850) was rebuilt into the structure we see today, with the distinctive tower and spire dating from after the First World War apparently a copy of one seen from his honeymoon hotel window in Switzerland. Marion created a garden adjoining Capstan Square, which her husband enclosed with a timbered wall, reputedly from deck supports from the HMS *Royal George* (launched in 1756, sunk off Spithead in 1782 with the loss of 900 lives.) From 1910 onward Wyllie championed the preservation of HMS *Victory*, Nelson's best-known flagship, launched in 1765, harbour ship in 1824–1922, finally located in its dry dock in 1924. The *Victory* often featured in his works, but in 1928 he began his largest, most ambitious work, *The Panorama of the Battle of Trafalgar*, 42 foot by 12 foot, unveiled by George V in 1930. He continued painting, sailing and travelling to the end, eventually dying in London in 1931 and was buried (following a moving ceremony where he was accorded full naval honours) in the grounds of St Mary's Church, Portchester Castle, now next to his wife and daughters.

Two of his sons, William (1882–1916) and Robert (1888–1914), were killed in the First World War, while his daughter, Eva (b. 1888), tragically died in 1912. As for his other daughter, Aileen (1903–1987), an ex-R.A.D.A. student, Wyllie purchased the old tram shed located between Tower Street and Broad Street and converted it into a workshop/studio, complete with stage. This building was destroyed in the Second World War and has since been rebuilt as Capstan House; all that remains is the archway designed by Wyllie's chauffeur and handyman, Mr Jones, with the building's latitude and longitude – 50 degree 74 min 25 sec North and 1 degree 6 min 25 sec West. Until recently it was freestanding, but it has since been incorporated into a new extension. In her later life Aileen lived at Black Horse Cottage, letting her father's beloved Sea Scouts use the garden. Tower House was eventually divided into six flats around 1976.

35. The Former St Patrick's Chapel, Eastfield Road, 1906

As we have already seen with St Jude's, as the Portsea Island population grew throughout the nineteenth and twentieth centuries, so too the apparent urgent need for spiritual and religious salvation. Numerous churches appeared during this time, and many have subsequently vanished again, destroyed in the Second World War, deconsecrated and demolished by an indifferent town or city council, or – perhaps the lucky few – able to survive in a new function. Once such is the small but quite delightful Mission Chapel of St Patrick in Eastfield Road, Eastney, off Winter Road. John Offord (1989) barely gives it a mention, although he does include a photograph of the simple, elegant interior. By contrast Rodney Hubbuck (1969, revised in 1976) calls it, 'A rum fighting-mad little mission church in dark red brick with weird cannon pilasters and heavy moulded gables. The excellent [east] end flanked by curious domed turrets is one of the city's hidden architectural joys. Alas, the interior is vacuous and disappointing!' David W. Lloyd is somewhat more restrained, remarking that it 'is strangely designed,

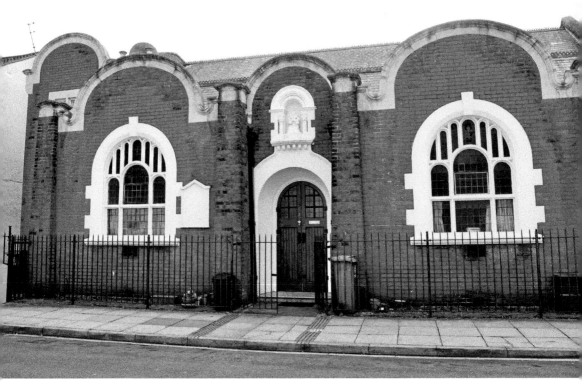

The former St Patrick's Chapel, 2011.

in brick and stone, in an Art Nouveau style, with odd straights and curves and tapering columns, and windows with arty adaptations of Gothic style tracery'. It was designed in 1906 by versatile local architect G. E. Smith, who designed the rebuilt South Parade Pier two years later. It is referred to in the *Kelly's Street Directory* as 'St Patrick Church Hall'. It apparently ceased to be a church in 1992 and is now divided into three apartments.

36. Park Building, Former Municipal College, King Henry I Street, 1908

Higher education in Portsmouth originated with the founding of the Portsmouth and Gosport School of Science and Art in 1869. This evolved into the Borough of Portsmouth Municipal Technical Institute, based in Arundel Street, which was subsequently renamed with the opening of the Municipal College of Science, Arts, Technology, Commerce, and Pure and Applied Art building (now Park Building) on the 10 September 1908, in what was then called Park Road, since renamed in 1970 as King Henry I Street. Four years previous, on 22 July 1904, Mayor John Edward Pink had laid the foundation stone to the new building in the company of the then chairman of the Higher Education Committee, Councillor F. G. Foster, and it was Foster, himself now mayor (but also a widower), who opened the new

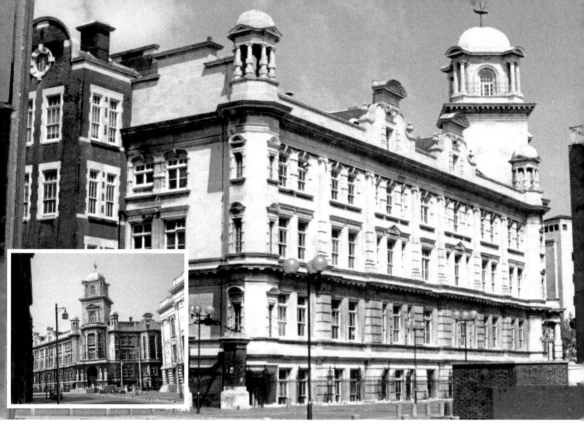

Park Building, the former Municipal College, both as seen in the 1970s.

Municipal College building, together with his five-year-old daughter Doris, who, uniquely, had been installed as his mayoress. According to William G. Gates, young Doris was a charming success, during which time she raised £1,000 for a hospital's children's ward, gave a 'birthing party' to Crimean and Indian Mutiny veterans, and received the German-born Princess Helena of Waldeck and Pyrmont (1861–1922, married to Prince Leopold, Duke of Albany, youngest son of Queen Victoria), Dowager Duchess of Albany, following his death in 1905 when she came to lay the foundation stone of the Wesleyan Sailors' and Soldiers' Home in Edinburgh Road. Quite the mayoress!

The architect was G. E. Smith, and the contractors were Armitage & Hodgson of Leeds, who had built the Guildhall next door. The cost was £120,000. In addition to the College of Art and a Teachers' Training College, it also housed the Central Public Library until that moved to its new premises next to the Civic Centre in 1976. The college continued to evolve, becoming Portsmouth Polytechnic in 1969 and the University of Portsmouth in 1992. In the 1970s Park Building housed the Physics, Pharmacy and Architecture departments. The elegant civic grandeur of Smith's building still makes it a favourite of mine, which would be worthy to grace any major city. Park Building was renovated and reopened in June 1997, this time by Lord Mayor Councillor Tony Golds. It was Grade II listed in 1972. The photographs show a view in 1988, and an earlier view from the late 1970s.

37. The Former Palace Cinema, now the Astoria Nightclub,
Guildhall Walk, 1921

Sadly now rather overshadowed by mostly undistinguished office blocks
and university buildings, the delightfully eccentric Palace Picture House was
situated at the southern end of Commercial Street, Nos 34–36, what is now on
the corner of the junction of Guildhall Walk and Winston Churchill Avenue. It
was designed by local architect A. E. Cogswell, and, given that he apparently
served with the Artists' Rifles in the Indian Army during the First World War,
it has a wonderful, eclectic and oriental style, like a miniature Mogul palace. It
was built by Frank Privett, and opened on 21 February 1921. Most local history
book sources state that the first film shown was *King Solomon's Mines* (from
the book by H. Rider Haggard), but the first movie version of that book I can
discover is from 1937, starring Paul Robeson and Cedric Hardwicke. There
were, however, two silent movie versions of *She* (also Haggard and directed by
Kenean Buel) by Fox Film, but are now lost. Unlike some other cinemas, the
Palace remained in the independent ownership of Portsmouth Town Cinemas
Ltd. Another design oddity was that when you entered the auditorium, the
projection box was facing you and the screen was behind. Seating capacity
was given as 630. In 1941 it was bomb damaged, but was repaired within five

The former Palace Cinema, 2015.

weeks, opening again as 'business as usual'. Destruction was threatened again in the early 1970s, when it was to be replaced by a glass monster spanning Guildhall Walk as part of Lord Esher's 'civic island' master plan. Celia Clark of the Portsmouth Society (founded in 1973), together with the cinema historian Dennis Sharp and the then owners EMI, were among those who successfully campaigned to save it. Not long after, in the more sexually liberated 1970s, it was renamed the Palace Continental, and featured films 'of a rather more adult type', but eventually it closed in 1981 and was converted into a nightclub around 1986. By then the address was No. 37/9 Guildhall Walk, but for some years the exterior was very shabby and neglected. Formerly Martine's, in 1999 it was Club Uropa, later still Route66, and then PURE, but from 2013 it became The Astoria. Grade II listed in 2000, it has undergone a magnificent £1-million exterior restoration by Just Develop It.

38. The Former Plaza Cinema, Victoria Road North, 1928

Kelly's Directory for 1951 lists nineteen cinemas in Portsmouth, but by its penultimate edition in 1975 that number had shrunk to just nine. Alas, not only have the cinemas closed, but all too often the magnificent buildings themselves have been needlessly demolished, to be replaced by something – at best – bland

The former Plaza Cinema, 2015.

and visually uninspiring. At least one exception is the former Plaza Super Cinema at Bradford Junction, Southsea, which was opened on 29 September 1928 and is now the Jami Mosque, said to be one of the largest in the south of England. Designed by local architects Henry J. Dyer & Son and with a seating capacity of 1,750, even its interior was opulent and extraordinary, with the entrance hall in Tudor style, cloud effects on the ceiling, and an open colonnade depicting on one side the Grand Canal in Venice and on the other side the view of an Italian garden. From 1928 to 1931 ownership was registered as Plaza (Portsmouth) Ltd, after which the licence was transferred to Associated Provincial Picture House Ltd. Ron Brown's *Cinemas and Theatres of Portsmouth* book contains a fascinating group photograph of the staff, many in smart braided uniforms. In total there are nineteen members of staff, including the manager, thirteen being women. The story goes that in January 1929 there was a fire in the projection room resulting in £3,000 of damage to the machinery, following which the management desperately tried to locate replacement equipment, and it was this that enabled the Plaza to show the first fully talking movie, Al Jolson's *The Singing Fool*, on 28 January – not just a first in Portsmouth but at that date anywhere outside of London! Later it became the Gaumont, but it ceased to be a cinema in the late 1960s and was subsequently converted into a bingo hall, which it still was in 1995 when it was finally Grade II listed.

39. Former Portsmouth Corporation Transport Head Office, now Southsea Police Station, Highland Road, 1932

Although urban public transport in Portsmouth began as long ago as 1840, and the first horse tram from 1865, it was only in the 1890s that Portsmouth Corporation took control, and by the 1930s there was an extensive bus, trolleybus and tram network spread across Portsea Island. Electric trams were introduced in 1901, originally under the Provincial Tramways Co., but it was not until 1919 the first motor buses appeared, now run under the Portsmouth Corporation Transport banner. The livery was changed from scarlet and ochre to red and white in 1931. In 1934 the then general manager, Ben Hall, proposed scrapping trams, and the last tram was withdrawn from service in November 1936. They were replaced, in part, by trolleybuses from 1934 until July 1963. The concept of one-person buses was introduced as early as 1958.

In 1927 what became Portsmouth City Passenger Transport Department (CPPTD) purchased a 3-acre site at Eastney, intended mainly as a central depot for motor buses, although at first they continued to keep some trams based there in addition to the main depot at Gladys Avenue, North End (a site that was only demolished in 1983). This bus depot eventually closed in May 1991, by which time the 1986 bus deregulation had seen the bus company

become Portsmouth City Transport, then Portsmouth City Bus in 1988, to
be taken over by Stagecoach in 1989, and Transit Holding in 1991, when it
became Red Admiral, then First Bus in 1996, and finally First Hampshire and
First Provincial. The depot itself was finally sold and demolished, and is now
a car park and a small housing estate, Carpenter Close, leading off Methuen
Road.

What remains is the former administration offices facing onto Highland
Road, designed by Henry J. Dyer & Sons of Victoria Road North, Southsea,
built by Messer S. Salter (Portsmouth) Ltd. It was opened on 22 January 1932
by the Lord Mayor and Mayoress Alderman F. J. and Mrs Foster. The front
elevation is neo-Georgian with Portland stone dressing over brick, and the
interior was planned to 'centralize all [city transport] departments' and to be
'easily adaptable to modern requirements', to quote the *Evening News* article
at the time. It was taken over in 1992 by Hampshire Constabulary, designated
in April 1994 as Southsea Police Station, but – like Kingston Crescent and
Cosham – has closed to public access since around 2013. Fears have been
raised that this fine building could still be sold off and demolished, as it is only
on the local list, which means the council would like it to be preserved but
gives no legal protection.

The former Portsmouth Corporation Transport head office, now Southsea Police Station, 2016.

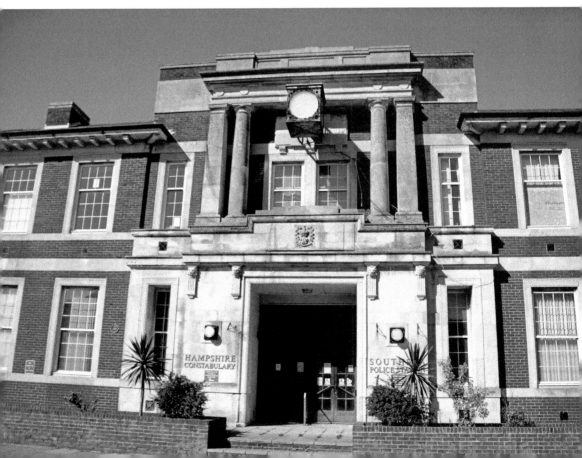

40. St Mark's Church, Derby Road, North End, 1970

The large-scale 1898 OS map of 'Portsmouth North End' shows a very different landscape to that of today. This really was the northern extremity of urban Portsmouth, with Walker Road and North End Road being the limit of housing. The Provincial Tramways Co. Depot was in Gladys Avenue, beyond which were open land, factories and brickworks until the Hilsea Ramparts. Drayton Road was the furthest development east, then more agricultural land and allotment gardens, with Stubbington Lodge in splendid isolation, and just a scattering of cottages and farms along the Copnor Road. The original St Mark's Church was shown on the south side of the junction of Derby Road and London Road.

It was a mere thirty years earlier, by the late 1860s, that the population had started to grow such that Revd S. Lidbetter decided to build a new church on land given by Winchester College. The foundation stone was laid on 23 December 1872, and the church was designed by Arthur Blomfield, who had previously rebuilt St Mary's in Fratton, while the builder was a 'Mr Quick of Southsea'. Completed in 1874 at a cost of £2,904, in appearance it is a sturdy, typically medium-sized Victorian church, initially with no south aisle (which was added in 1899) while the vestry was constructed in 1888. In 1898 the quite lofty belfry, or Italian-style campanile, was also built, costing as much again as the original church (£3,000). The baptistery was extended in 1910, while in 1946 new windows replaced those damaged in 1941.

St Mark's Church, 2013.

Inset: St Mark's emblem.

However, by 1967 increasing costs for heating, together with what was now a rather large and draughty building needing a lot of maintenance, prompted the Church Committee to decide to demolish the old church and build anew, the site being subsequently sold and now occupied by a large, rather ugly retail and office unit. The new church, in a style distinctly modernist and incorporating both 'worship' and 'social' areas, was built on the site of the old Vicarage on the north side of Derby Road. The architect was Brighton-born-and-based John Wells-Thorpe (b. 1928), who designed a number of modern post-war churches locally, as well as Hove Town Hall in 1974. It was consecrated on 10 October 1970.

The stylised bronze sculpture of the emblem of St Mark was a gift from St John's, Wilmingon, Delaware, USA. John Offord remarked upon its 'resemblance to the logo of a well-known brand of lager', but I actually like it. Like the church itself, it is in a modern mode, but interesting in its conception. The plain-brick exterior does have a box-like severity to it, and the concrete ramp in front leaves much to be desired, although the powerful 'tower' with its simple cross emblem is quite striking. More successful perhaps is the interior: light, spacious and functional. The Community Café was opened in 2008 with its motto 'stay as long as you like!'

41. 'Bucklands Wall', Grafton Street/Estella Road, 1972

Approaching Portsmouth along the M275 across Tipner Lake and past Whale Island to the Rudmore Roundabout flyover, with the 1976 Continental Ferry Port on the right, one cannot help but observe the red-brick, six-storey 'Bucklands Wall', an interesting example of linear municipal housing, built at a time when the favoured mode was still for high-rise tower blocks, as seen in nearby Somers Town. Extending in a series of blocks, some connected by concrete pedestrian bridges, from just beyond the vehicular cul-de-sac that is now Old Commercial Road, along the original Grafton Street, and now incorporating Estella Road as far as Garfield Road, they were built around 1972 and designed by city architect W. D. Worden. Compared to a lot of the quite awful concrete housing estates being constructed, then and since, I personally like them. Architecturally, and perhaps even socially, they are very much in the tradition of the nineteenth-century London-based Peabody Trust Housing Association estates (founded in 1862 and named after the American banker George Peabody, 1795–1869), but in appearance they are also not dissimilar to the better-known, 1½-mile-long, 1,800-home Byker Wall estate in Newcastle upon Tyne, designed and constructed in 1968–82 by the architect Ralph Erskine, assisted by Vernon Gracie. However, unlike its more modest Portsmouth equivalent, the Baker Wall estate has won frequent architectural acclaim, as well as being awarded Grade II-listing status in 2007.

Partially screened by trees with its own road access front and back, the west side, facing the ever-busy Mile End Road dual carriageway, is distinguished by

Three views of Bucklands Wall's. The third view shows the rear of Ferry House B & B (2016).

long external corridor balconies (now with multicoloured panels), while the lower-storey flats have house-like front-door porches and attached shed-like 'outhouses'. The windows this side are small, being mostly bathrooms or kitchens, the living rooms and bedrooms (with alternating individual panel or brick-fronted balconies) being on the east side, looking across the rest of the low-rise housing. The ground floor is given over to residential car parking. Estella Road has 189 units, while Grafton Street has 119.

Once situated on the corner of a residential street but now standing in nearby isolation is Ferry House Lodge, No. 472 Mile End Road, formerly the Market House Tavern, dating from around 1840–50 and Grade II listed in 1972 following plans to demolish it and replace with a hotel. It was originally owned by the Pike Spicer Brewery, subsequently acquired by Brickwood's (later Whitbread), before being sold to a group of local businessmen, and is now a bed and breakfast hostelry.

42. Civic Centre Complex, Guildhall Square, 1976

In 1941–43, even while the bombs were still falling, the then deputy city architect F. A. C. Maunder was submitting ambitious and far-sighted plans for the redevelopment of, among other things, a new civic centre located in a grid eastwards of the Guildhall. In 1948–49, city planning architect T. L. Marshall upgraded Maunder's plan, with a new east–west road parallel to the railway, shops and offices on one side, a T-shaped civic centre opposite (with a civic theatre behind, facing what later became Winston Churchill Avenue), then a library, art gallery and museum complex and health centre and college of art beyond that. Of this, what did get built eventually was the law courts (1960) and the Central Police Headquarters (1959). This proposal, reproduced in John Stedman's 'Portsmouth Papers No. 66', was rational, ambitious and actually quite attractive, *had it been built*. Following delays and distractions, in 1960–61 a completely new plan was submitted by private developers proposing that Guildhall Square be transformed into a large rectangular roundabout 'with trees, lawns and fountains', but surrounded by up to eighty shops, a department store, hotel, offices, flats and a multistorey car park. Thankfully the Ministry of Transport killed that idea!

Finally, in 1963 the firm of Brett & Pollen, with Lionel Gordon Baliol Brett (1913–2004, 4th Viscount Esher) as head, was commissioned to prepare yet *another* plan for the redevelopment of the 38-acre (15-hectare) site. From 1947 to 1959 Brett was one of the architects and town planners involved in implementing the construction of Hatfield New Town, and he only became Lord Esher in 1963, with the death of his father, Oliver Sylvain Baliol Brett. Even before his final master plan was published in 1970, work was already underway (1967–69) clearing away those buildings on the east side of Commercial Street (now Guildhall Walk) that had survived the Second World War. The next fundamental change was the rerouting of vehicular traffic along what is now Isambard Brunel

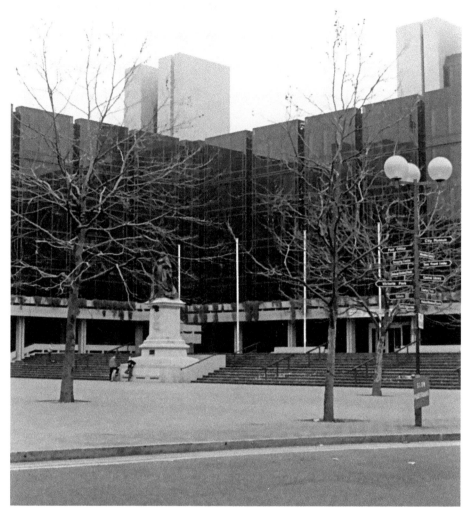

Civic Centre Complex from Guildhall Square, *c.* 1988.

Road into Winston Churchill Avenue, thereby enabling the pedestrianization of Guildhall Square as the large and attractive – almost continental – public space it still is today. Enterprise House, next to the railway station, by Richard Leggatt Partnerships (1970–74) has recently been reconstructed as a Premier Inn, while most of the other buildings here are now part of the university.

By 1972 construction had begun and was completed in 1976, the architectural consultants Teggin & Taylor having taken over but keeping to the spirit of the Esher plan. In December 1972 Alfred Dury's 1903 statue of Queen Victoria was moved to its new position in front of the sweep of steps to the east wing of the new Civic Offices. Unashamedly modernist in its concept, nevertheless it combines a simple elegance and civic grandeur, together with a more human scale. Both Lord Esher and later Harry Teggin explained their rationale that the restored

Above: The Civic Offices, looking towards Guildhall Walk (now more obscured by trees).

Below: The Norrish Library building, from Dorothy Dymond Street.

The Civic Centre, from Isambard Brunel Road, looking towards Winston Churchill Avenue before the twenty-first-century renovations.

late Victorian Guildhall would remain the dominant structure, the brown mirror-glass-fronted new offices not exceeding seven storeys – 'no higher than the top of the Guildhall balustrade' – while the square itself is 'not so large as to seem bleak and under-used'. My photographs date from around 1988, and since then the trees planted along the south side have now matured. A pedestrian mall links the square with the law courts and Central Police Station, while on the south side, where Russell Street once was, is now the Norrish Central Library (built in 1975–77 and named after deputy city architect Ken Norrish), its design 'somewhat copied from Frank Lloyd Wright's Guggenheim Museum in New York'.

43. Former Churchill House, now University House, Winston Churchill Avenue, 1986

Styles and tastes change, never more so than in architecture. By the 1980s the original Lord Esher plan for the Guildhall quarter was already being modified, especially along Winston Churchill Avenue where we see some of the earliest and still-attractive examples of Portsmouth post-modernism in what was originally Churchill House, designed by local architect Hedley Greentree in 1985, who also designed nearby Hippodrome House in Guildhall Walk. Personally I think the Churchill House design may resemble the prowl of a ship, but others think of it as like a black bat! The simple foundation stone,

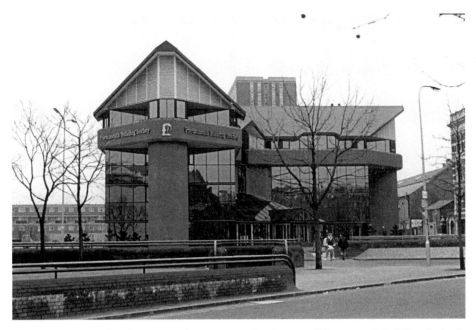

University House. This photo was taken in 1988 when it was still Portsmouth Building Society's head office. It is now more obscured by trees.

dated 24 April 1986, can still be seen, giving the then Portsmouth Lord Mayor as Councillor Fred Warner. My photograph shows it in around 1988, when it was still the headquarters of the then Portsmouth Building Society. This, however, was taken over by the Cheltenham & Gloucester Building Society in June 1991, one of sixteen smaller localised building societies absorbed into the C & G 'empire' between 1984 and 1993. Alas in 1995 C & G too fell victim to a takeover by Lloyds TSB, although for some years after it continued to operate as a separate bank within the Lloyds Group, despite extensive branch closures in 2007 and again in 2009. Finally it was rebranded as part of TSB Bank in 2013 and thereafter C & G too ceased to exist.

Within six months of the original C & G acquisition of Portsmouth Building Society, Churchill House was sold to the polytechnic in December 1991, the name changing to University House in July 1992 to coincide with the upgrade to university status. It is now the vice-chancellor's office, and central office for registry and administration, one of thirty major university buildings on the campus between Ravelin Park, Guildhall Square and Queen Street.

44. Pyramids Centre, Southsea, 1988

Despite a change of tourism strategy in the early 1980s away from promoting Southsea as a seaside resort to emphasizing Portsmouth's maritime heritage, the city council also still wished to offer more facilities for the traditional

holidaymaker other than the Sea Life Centre. Therefore in July 1986 planning permission was granted for a water leisure swimming pool complex and conference centre to be built on the site of the rather rundown Rock Gardens Pavilion. So the architecturally distinctive Pyramids Centre came into being, which opened to the public in July 1988. It was developed by Leeds-based Clifford Barnett Developments in partnership with the city council, and the architects

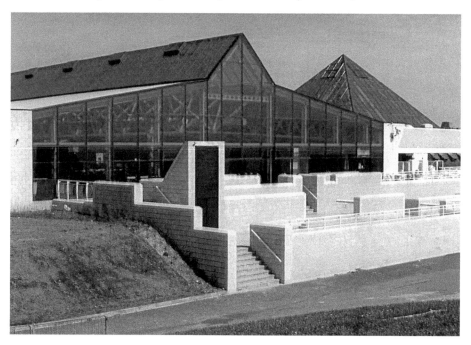

Pyramids Centre, 1990s, but externally looking much the same as it does today.

were Charles Smith, Boston Spa, West Yorkshire. It cost £8.5million and was
initially managed by J. Lyons Catering Ltd and Clifford Barnett. Unfortunately
what followed became dubbed the Pyramids 'curse' by local media, as a series
of mishaps, low attendance at the turnstiles and dissatisfied customers resulted
in a £416,300 operating loss for 1989/90. Increasingly saddled with what now
appeared to be a financial white elephant, the council would still have to pay
the mortgage even if the centre closed. Eventually in February 1990 the council
took over the management, controlled by Portsmouth Operating Co. Ltd, whose
directors were included in the Chair of the Leisure Committee. Changes were
made, including membership special offers, and the Oasis Terrace, originally
with French and American catering, later in 1993 the 'Frog On The Front', a
wine bar/nightclub.

However the centre continued to make a loss, and by 2007 faced with an
overall twenty-five-year repair bill of £9.5million, of which £1.8million would
be just on the Pyramids, and a 98 per cent increase on operational costs from
the previous ten years. The council seriously considered shutting and selling it
off, just in order to save their other leisure venues. Briefly, in 2008, there were
plans to convert it into an ice rink, but still there were the long-term structural
problems to be dealt with, many relating to weather damage, vandalism, wear
and tear, and general maintenance. Roof screws rusted, glass roof and side
panels alone cost £2,000 each, chlorine had corroded the air-handling plant
and filtration tanks, walls had to be removed to install new bolder systems,
while repairing the roof alone was estimated to cost £140,000. The next crisis
came with severe storm damage in February 2014, which necessitated closure
until the following September and an extensive, some might say long-overdue,
£1-million refurbishment, together with the installation of flood barriers and
improvements to the sea defences. The centre has now reopened, operated
by Bournemouth-based BH Live, still in partnership with the city council,
and now includes function rooms, a gym, fitness studio and spa, together
with an adventure world and pool. It is also a popular venue for live music
performances.

45. Cascades Shopping Mall, Commercial Road, 1989

So far the Cascades Shopping Centre has survived, while the more controversial
Tricorn Centre, designed by Owen Luder (b. 1928) and Rodney Gordon
(1933–2008) and completed in 1966, has since vanished, demolished in 2004
and is now (2016) a ground-level car park accessed from Marketway and
Charlotte Street. In 1974 David W. Lloyd described the Tricorn as 'a romantic
piece of 'concrete sculpture' on a large scale, conceived at a time when
visibly daring construction in concrete, exploiting unusual shapes, was very
fashionable'. While by no means unique among British townscapes for that
period, the Tricorn became especially hated, in the 1980s being voted the third

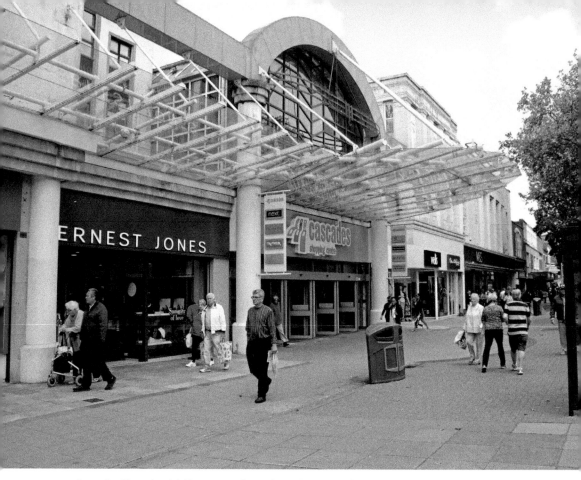

Cascades Shopping Mall entrance, from the pedestrianized Commercial Road (2013).

ugliest building in the UK and compared to 'a mildewed lump of elephant droppings' by Prince Charles. Others saw it as an 'irreplaceable example of Brutalist architecture', and Jonathan Meades even compared it to Stonehenge or Lincoln Cathedral! Presumably they never had to shop, work or live there, or negotiate its 'dark, damp and poorly ventilated' interior spaces at night. As early as 1979 there was only one tenant still residing in the eight flats, and by 2002 all the forty-eight shops were empty. It had initially cost the city council £2 million to build, but attempts to have it listed or renovated failed to save it from public opinion.

By contrast the Cascades is better integrated into the city centre, with entrances in Charlotte Street, Spring Street and Commercial Road, which was itself pedestrianized in 1972, extending as far as Arundel Street and Edinburgh Road in 1977. Construction began in 1987, and it was opened in September 1989 by the Lord Mayor, Councillor Miss Gladys Howard. In addition to its own multistorey car park, the centre has sixty shop units, including many major high-street retailers. Sadly (as has since happened with Eastleigh's Swan Centre) the original, quite spacious, food hall area was converted into more car parking and

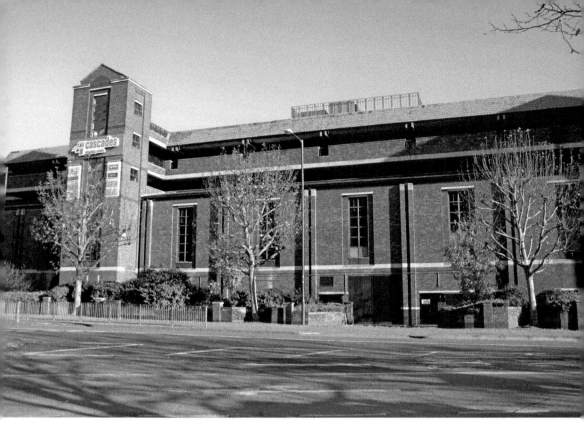

The multistorey car park from Unicorn Road (2016).

retail space, and the atrium filled in during the £20-million renovations to the ground and lower floors in 2006/7. It was reopened in May 2007 by Lord Mayor Councillor Mike Blake.

46. (Emirates) Spinnaker Tower, Gunwharf Quays, 2005

Almost inevitably the Spinnaker Tower has come to be the architectural symbol of Portsmouth, but it has not been without either controversy or critics. Originally planned as the 'Portsmouth Millennium Tower', and the visual centrepiece of the 2001 Gunwharf Quays development, construction did not actually begin until 2001, and it was only completed in 2005, following many delays and demands for extra funding. Before that the city's residents had been offered three design choices: the 'Globe', supported on two arms meant to represent Portsmouth and Gosport; the 'Triple Towers', in the image of a ship's bridge, representing the two town's industrial heritage; and the sail-shaped 'Spinnaker' – certainly the most attractive option. At 560 feet (170 metres) it is still (just) the tallest accessible structure in the UK outside of London. It was designed by local firm HGP Architects and engineering consultants Scott Wilson Group, while the builders were Mowlem (taken over by Carillion Plc in 2006),

Spinnaker Tower, now sponsored by Emirates, 2016.

who in 1944 were once employed in the building of Mulberry harbour units for D-Day. The steelwork was by Butterly Engineering and it has a projected lifetime of eighty years. Although owned by Portsmouth City Council, the tower is managed by York-based Continuum Leading Attractions, and in July 2015 a commercial sponsorship deal was agreed with Dubai-based Emirates Airline, when the tower was renamed the Emirates Spinnaker Tower, although the original proposal to repaint it red and white drew considerable local opposition – that being the team colours of local football rivals Southampton FC. A compromise was agreed and the colours are blue, gold and white.

Although part-funded by the National Lottery, construction ran over budget at £35.6 million, with the council contributing £11.1 million. Even at the official opening ceremony in October 2005, there were problems with the external glass elevator, and this was eventually removed in 2012, and (as that left only the one internal lift) an evacuation chair was installed for disabled visitors in the event of an emergency, and for those unable to navigate the 570 steps to ground level. In 2006 it won the Royal Institute of Chartered Surveyors project of the year award. In August 2016, at a cost of £46.2 million, Brighton opened its own observation tower next to the still-ruined West Pier, the 531-feet (162-metre) British Airways i360, but this lacks the grace of its Portsmouth rival and has already been dubbed the 'iSore' and 'the donut on a stick'.

47. Admiralty Tower, Admiralty Quarter, Queen Street, 2009

Until the Second World War Queen Street was narrow and of predominately Georgian period buildings with working-class streets (commerce and housing) tightly clustered cheek by jowl to the dockyard walls. However, by the 1960s this north side had been almost completely cleared for road widening. Now the dominant feature is the twenty-two-storey, 68-metre (223-foot) Admiralty Tower, one of the more recent additions to the Portsmouth skyline and a delightful alternative to the earlier modernist 1960s/70s office blocks like Brunel House, or the Le Corbusier-style high-rise housing that have blighted Somers Town. Reminiscent in design to Gio Ponti's iconic thirty-two-storey Pirelli Tower in Milan, it expresses a new post-modernist elegance, which we also see with the twenty-six-storey, 101-metre (331-foot) East Side Plaza (architect Broadway Malyan, 2005–08), located next to the Vernon Gate in Gunwharf. With seventy-six flats, it is the centrepiece of the Admiralty Quarter, a gated community with concierge service, located between Admiralty Road (the former Chapel Row), Bonfire Corner and Cross Street, an area which once comprised Hamburg Square and St Catherine's Row. Designed around 2005 by David Richmond & Partners, following a design competition for the site held by the Portsmouth Naval Base Property Trust, and constructed in 2006–09, in total there are 566 apartments in sixteen buildings including one block of social housing, complete with its own private, residents-only, podium garden with water features and trees on the roof of the two-storey car park.

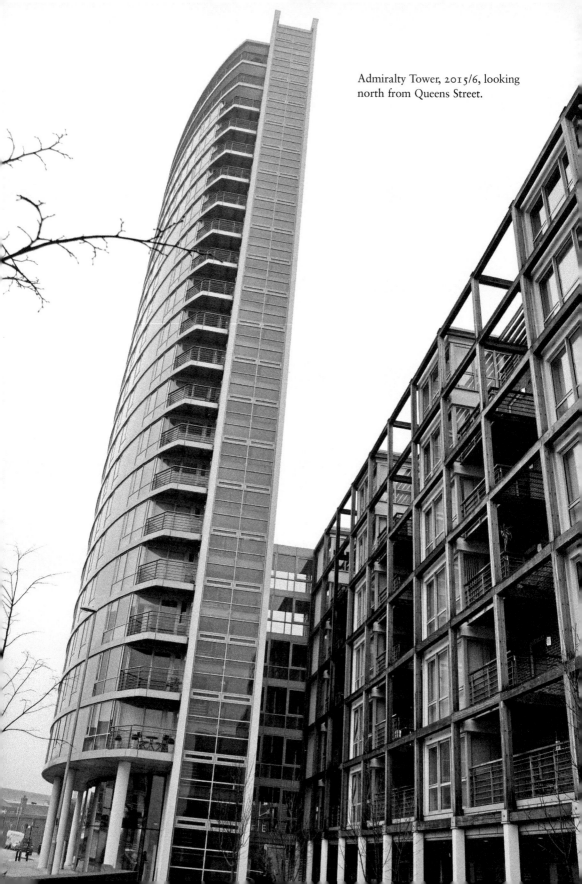

Admiralty Tower, 2015/6, looking north from Queens Street.

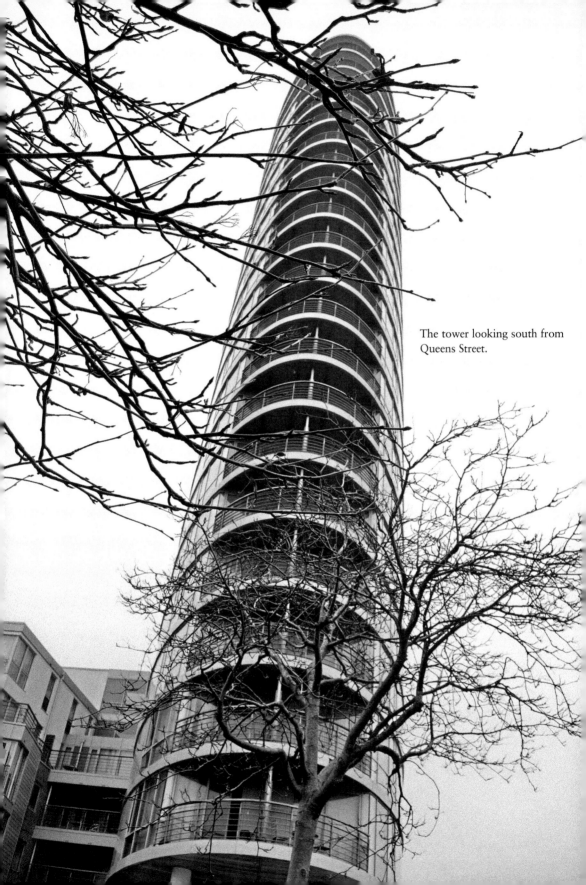

The tower looking south from Queens Street.

48. Mary Rose Museum, Naval Dockyard, 2013

The tragedy and triumph of the *Mary Rose* is another story now forever associated with Portsmouth. In July 1545 this carrack-type warship, originally constructed and launched in Portsmouth in 1510–11 and extensively rebuilt in 1536, was one of the largest at the time, a seemingly formidable fighting machine of 700–800 tonnes, between seventy-eight to ninety-one guns, and with a crew of 200 sailors, 185 soldiers and thirty gunners, and – having already seen much active service as flagship against the French and Bretons in 1512–13 and 1522–26 – was about to do further battle against a French invasion fleet in what became known as the Battle of the Solent. But then disaster struck. A possible combination of a sudden strong wind, open gun ports, the additional top-heavy weight of cannon, and perhaps even an insubordinate crew, resulted in her heeling over sufficiently that water flooded into the lower gun ports, and she sank rapidly with only thirty-five survivors. Contemporary attempts to salvage her retrieved only the rigging and some guns, although apparently the wreck was visible at low tide into the late 1500s. Later, having been buried beneath sand and silt, the wreck was briefly rediscovered in 1836, after which it was 1965 before the search was recommenced, with the first timber recovered in 1971. Even then legal and practical problems combined to delay any attempt at salvage until 1982, but, following the 1974 Protection of Wrecks Act, the site was declared to be of national historic interest and thereafter given full protection against trespass or

Mary Rose Museum, 2016.

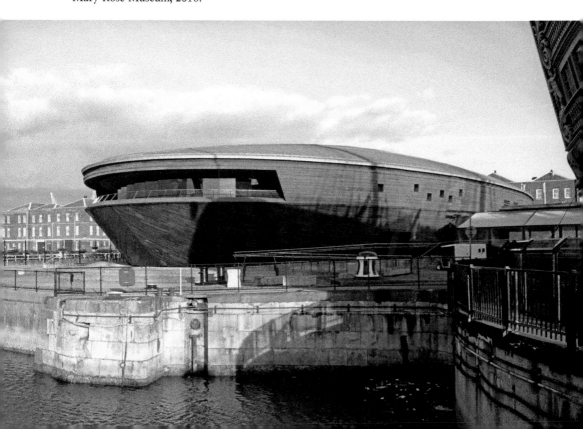

commercial exploitation. 1974 also saw the creation of the Mary Rose Committee – later Trust – under the royal patronage of Prince Charles.

Finally, after months of delays, wrangling and preparations, and in what was the most ambitious and expensive project of marine archaeology to date, October 1982 saw what now remained of the wreck raised from the seabed, using a specially constructed salvage cage. Years of conservation and preservation have followed, together with the recovery of over 26,000 artefacts and the remains of almost half the crew. Modern technology has since given a vivid snapshot of everyday life and even the physical appearance and diseases of this floating self-contained Tudor community. After some futile debate, the dockyards was the *Mary Rose's* inevitable final resting place, and the visitors' centre opened in October 1983, with a separate museum in No. 5 Boathouse opened in July 1984. Only much later, in September 2008, was the display hall closed to facilitate the construction of the new £35-million museum, designed by architects Williamson Eyre and built by construction firm Warings, over and around the ship while it sat in a dry dock. This amazing building, looking like a cross between Noah's Ark and a grounded flying saucer, was opened in May 2013. Conservation has continued, and only in 2016 was the sealed 'hot box' removed and the ship could at long last be revealed dry.

49. Somers Town Centre, aka 'The Hub', Straddling Winston Churchill Avenue, 2014

The 1950s and '60s redevelopment of Somers Town provides yet another object lesson on the contrasts between the highfalutin ideals of town planners and the often awful, dysfunctional, concrete-and-tarmac reality. Even in 1974 David W. Lloyd hinted at the inevitable outcome. Speaking of the 'area north of King's Road and west of Somers Road' he remarks, 'The character of the [post-war] rebuilding varies greatly' with 'the dominant features … four eighteen-storey blocks dating from the nineteen-sixties, design by Miall Rhys-Davies and Partners in association with the City Architect which was very much in vogue at the time, following the examples of the London County Council at Roehampton and elsewhere, and ultimately of Le Corbusier.' Later he makes comparisons to Park Hill, Sheffield and Cumbernauld New Town in Scotland, neither perhaps now regarded as urban success stories. In their regeneration plan for 2012 onward, the city council remarks that the destruction of the original grid street layout, to be replaced by 'super blocks', made the district virtually 'impermeable to traffic, with little clarity of routes for vehicles, pedestrians or cyclists'. The consequence was an almost ghetto mentality, isolation (not least living in those eighteen-storey high-rise towers), problems with under-education, drink and drug abuse, social deprivation and criminality.

Belatedly, the city authorities are attempting to reverse this situation, and one such shining improvement is Somerstown Central, aka 'The Community Hub', connecting

Above: The south side entrance to Somers Town Centre/'The Hub', Sedgeley Close, 2016.

Below: The west side of the centre as viewed from Winston Churchill Avenue.

Tyseley Road with Rivers Street across the dividing dual carriageway of Winston Churchill Avenue. Opened in July 2014 and described as a 'stunning aluminium-clad capsule' and 'an inhabited flyover', it has an interior curved eighteen-beam framework of Glulam timber from sustainable forests, and houses the new health centre (moved in 2015 from the 1971 building in Blackfriars Close), dental surgery, sports hall, local housing office, community cafeteria, book-lending club, youth club, plus educational facilities for older local residents. It has cost £10.8 million, and was developed from original 2009 proposals by Househam Henderson Architects and the Petersfield Co. Re-Format Architects, with the structural engineers AKS Ward and the internal, environmental and service engineers the Dutch Royal BAM Design Group.

50. Land Rover Ben Ainslie Racing Centre, Camber Quay, 2015

The Camber is a small natural haven probably used since prehistory. On an early map dated around 1542, a curved sandbar can be seen enclosing it, later to be where Broad Street and East Street/Town Quay is now. Throughout the nineteenth and for much of the twentieth centuries it was a place of hectic commerce and industry, surrounded by chandlers, warehouses, coalbunkers, and a huge shipbuilding yard alongside White Hart Road. Thankfully (for now) it is still a busy fishing port and market, but the tradition of boatbuilding in the Camber had ceased in 1985, when Vosper's (since 1966 renamed Vosper-Thorneycroft & Co. following their merger with the Woolston-, Southampton, based John I. Thorneycroft & Co.) finally moved out, having been based here since they were originally founded by Herbert Edward Vosper in 1871. What had been their boatyard is now King James Quay, fringed by Feltham Row, named after George Feltham, the local boatbuilder.

So, while the construction of the massive new £15-million Land Rover Ben Ainslie Racing (BAR) Centre building on what used to be called Town Quay, facing the Outer Camber, just across from the existing Wightlink Isle of Wight terminal at Gunwharf Quay, may seem visually intrusive to some, it has hopefully revived and reignited new life to Old Portsmouth, and should be congratulated for that. Record Olympic medal sailor Sir Charles Benedict ('Ben') Ainslie, CBE (knighted in 2013), born in 1977, first won silver in the 1996 Olympics, then gold in 2000, again in 2008 and 2012, and is one of what is a new generation of really influential British sporting heroes. Constructed in 2014–15, the interior designed by Ainslie's wife, Lady Georgina Ainslie (Georgie Thompson, *Sky News* sports presenter) and Lady Francesca Grade, the building – with its iconic 25-metre by 12-metre monotone Union flag design on the doors – is designated as a base and visitor centre for 'sailing operations, research and development, boatbuilding, sports science and fitness facilities', directly employing up to ninety jobs, and helped secure Portsmouth as the location for the America's Cup World Series in July 2016.

However, while certainly a major coup for Portsmouth, since 2015 a major political row has been brewing over the city council's decision to allow BAR not to start paying the £110,000 per year rental until the tenth year of the proposed fifty-year lease.

Above: Land Rover Ben Ainslie Racing Centre under construction in 2015.

Below: The finished building in 2016.

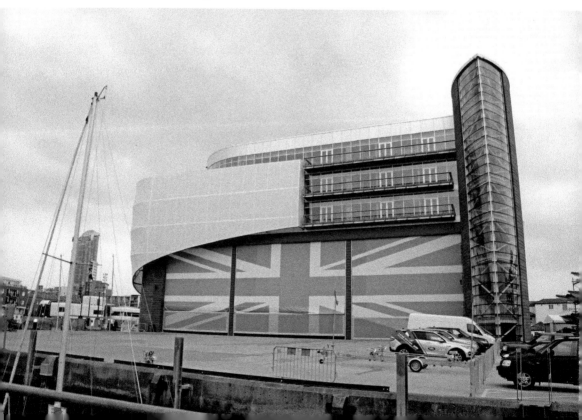